Best in Show

Dolly Faibyshev

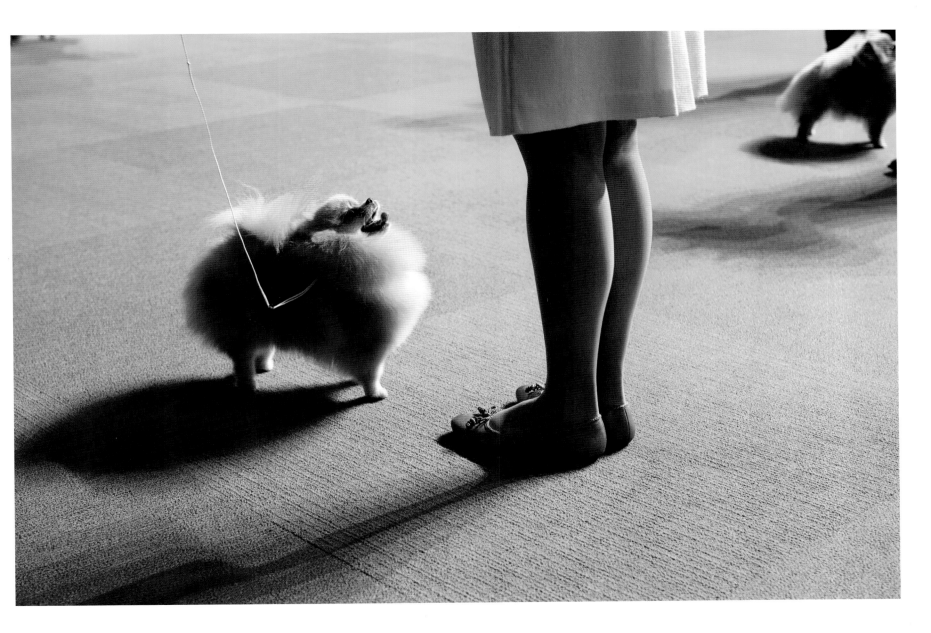

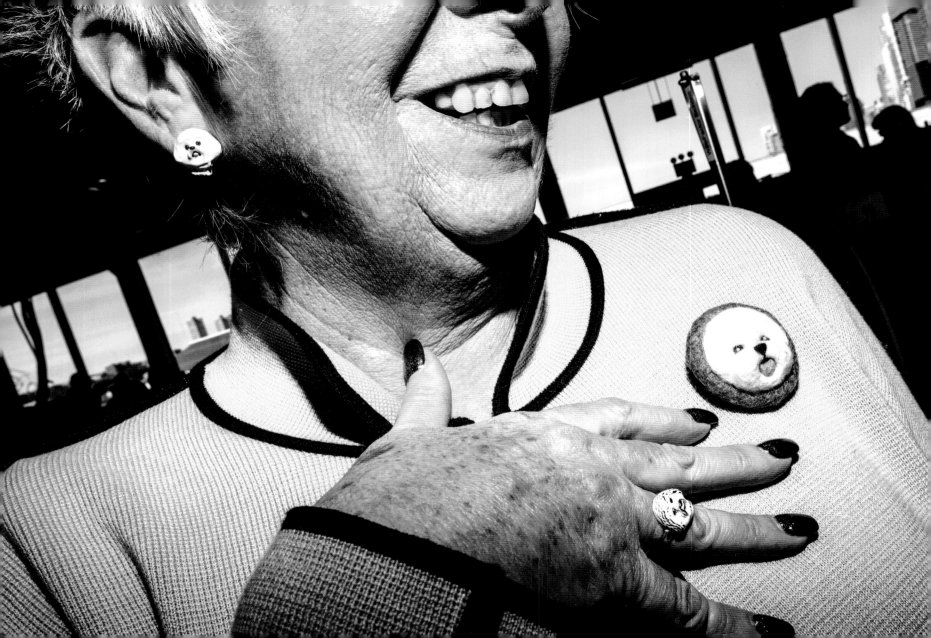

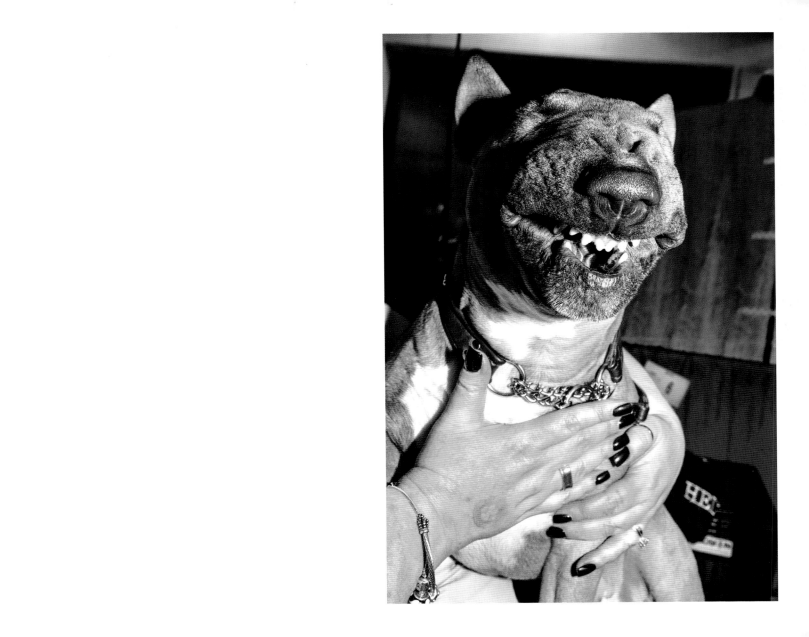

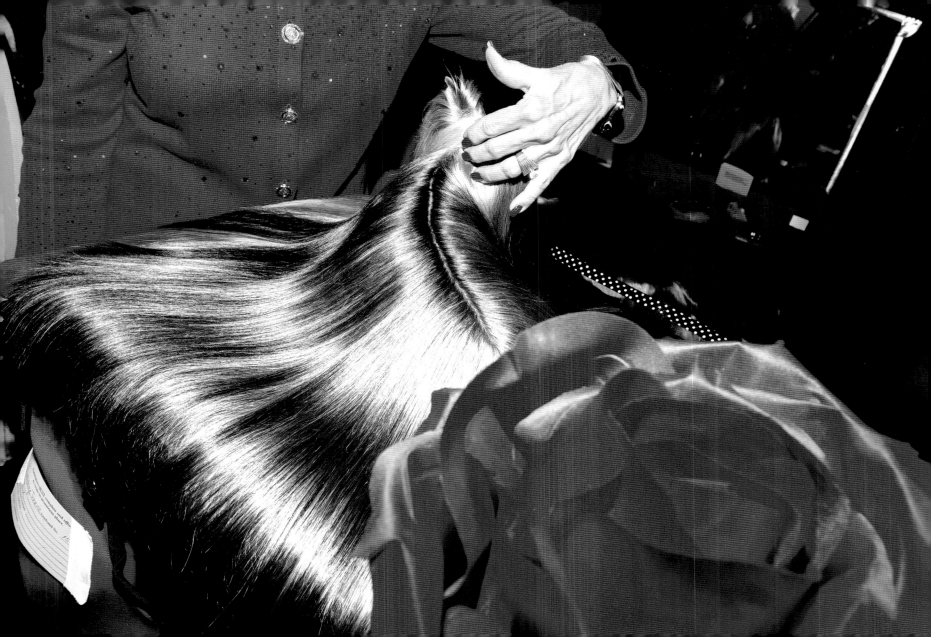

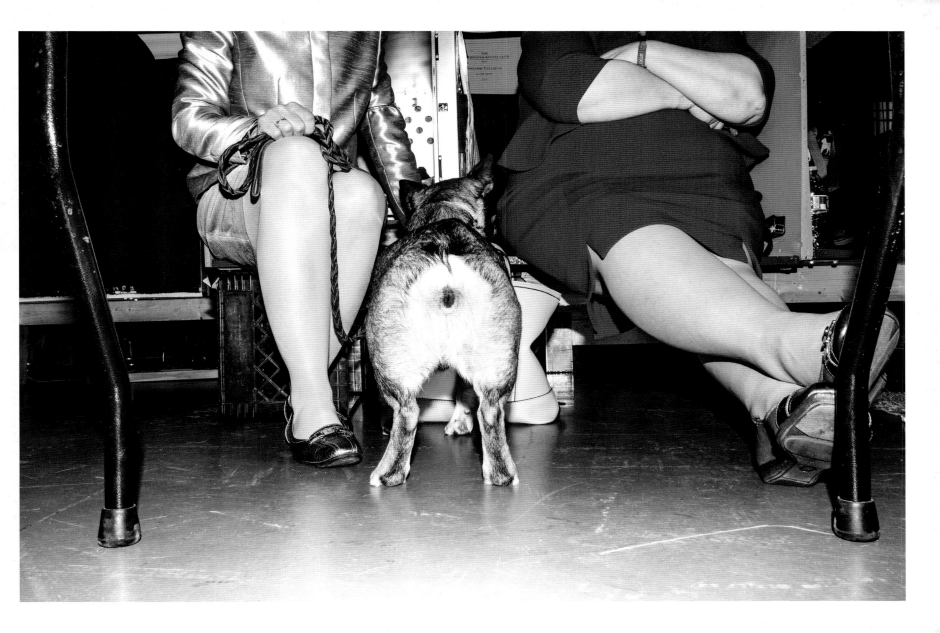

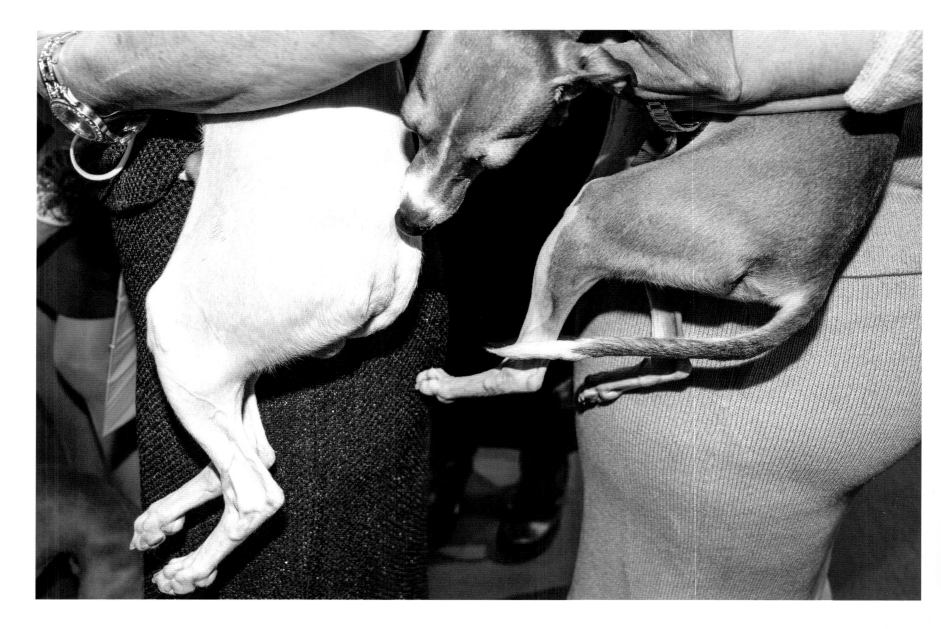

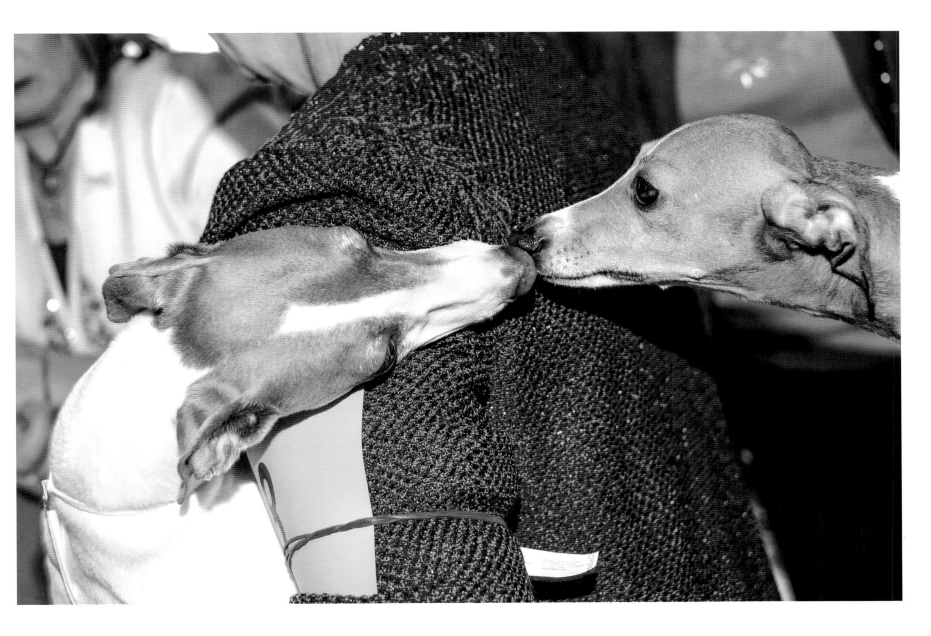

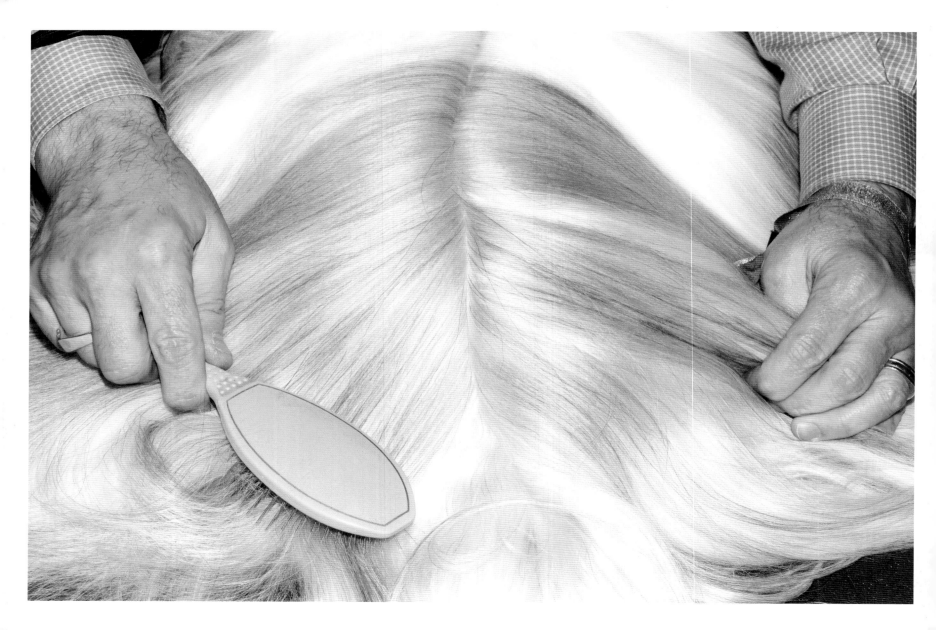

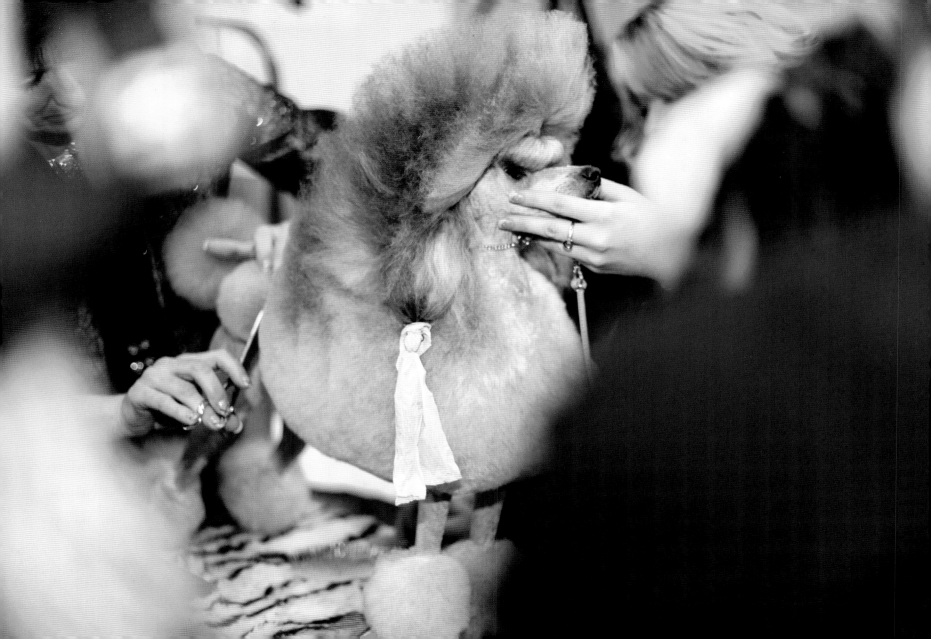

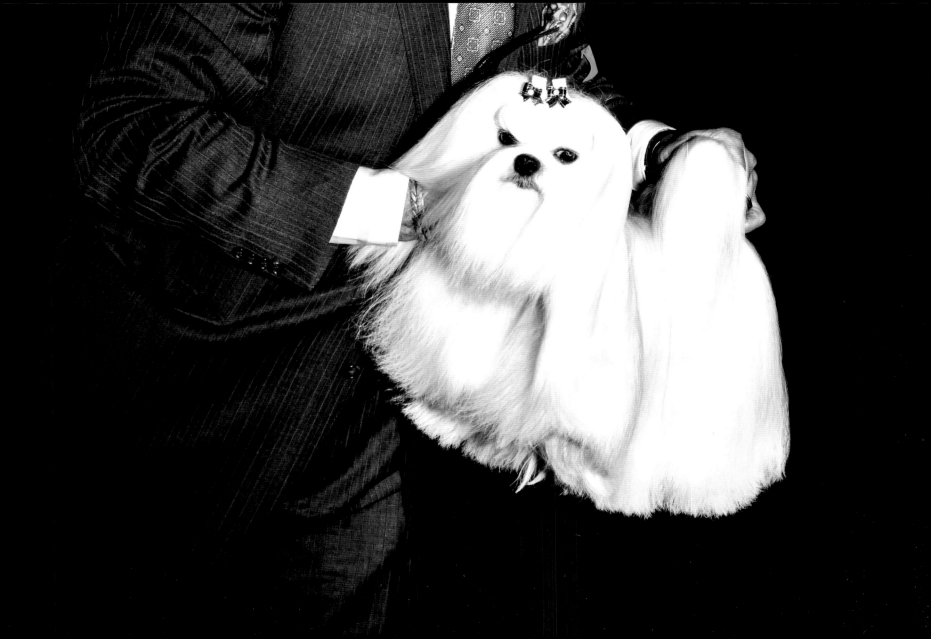

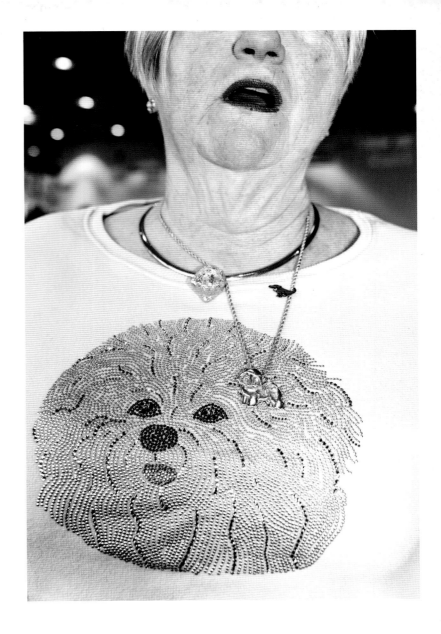

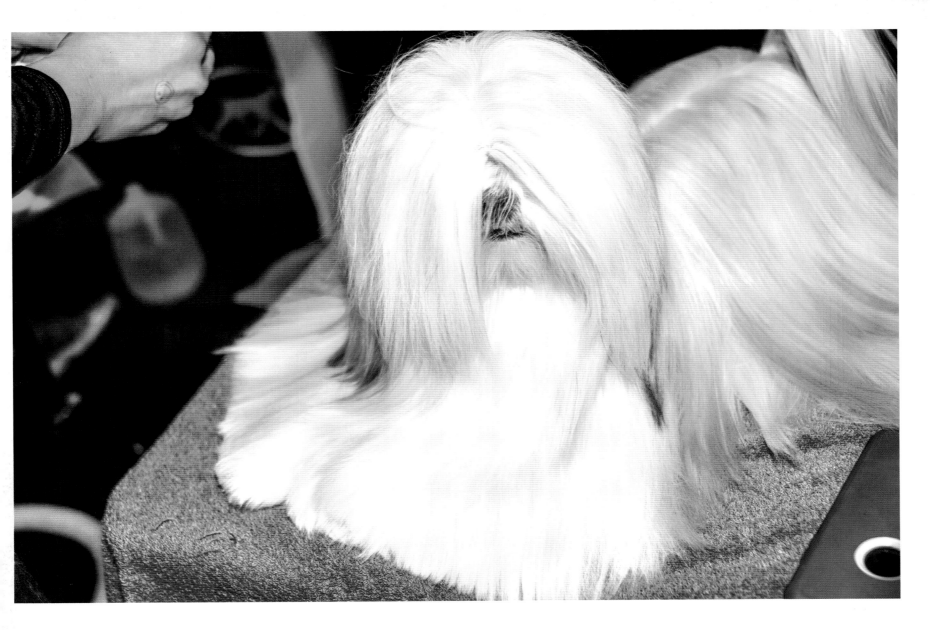

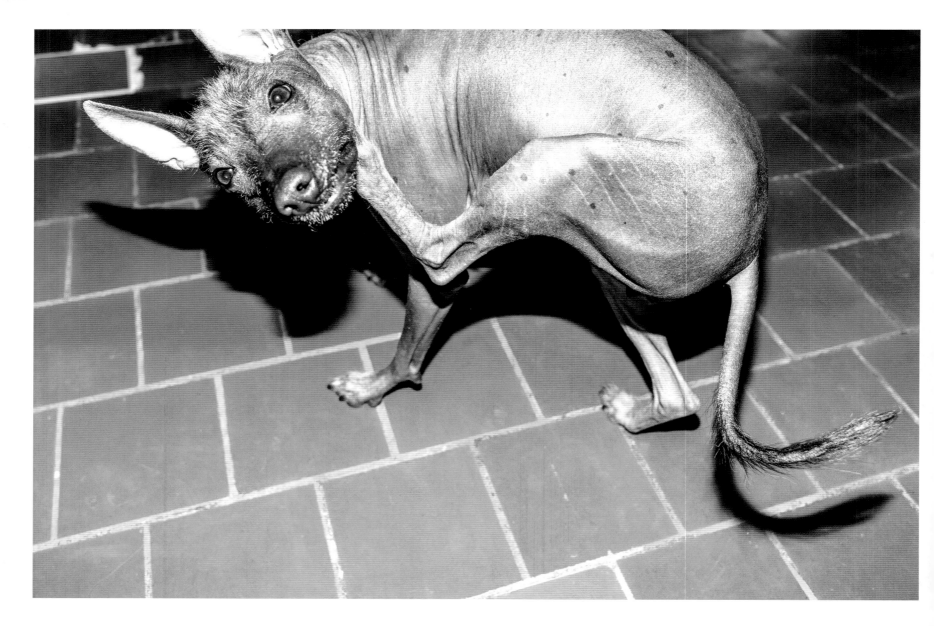

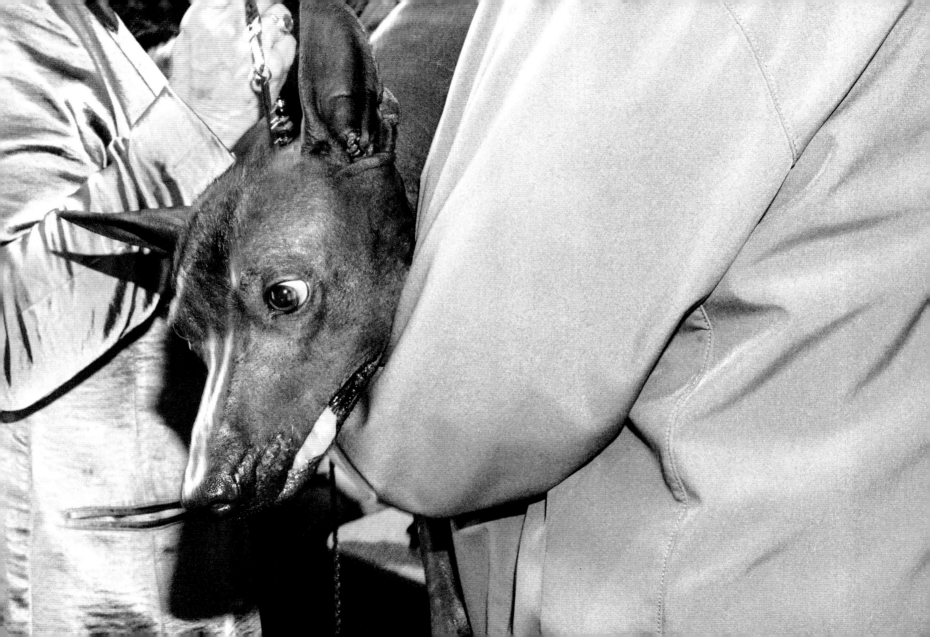

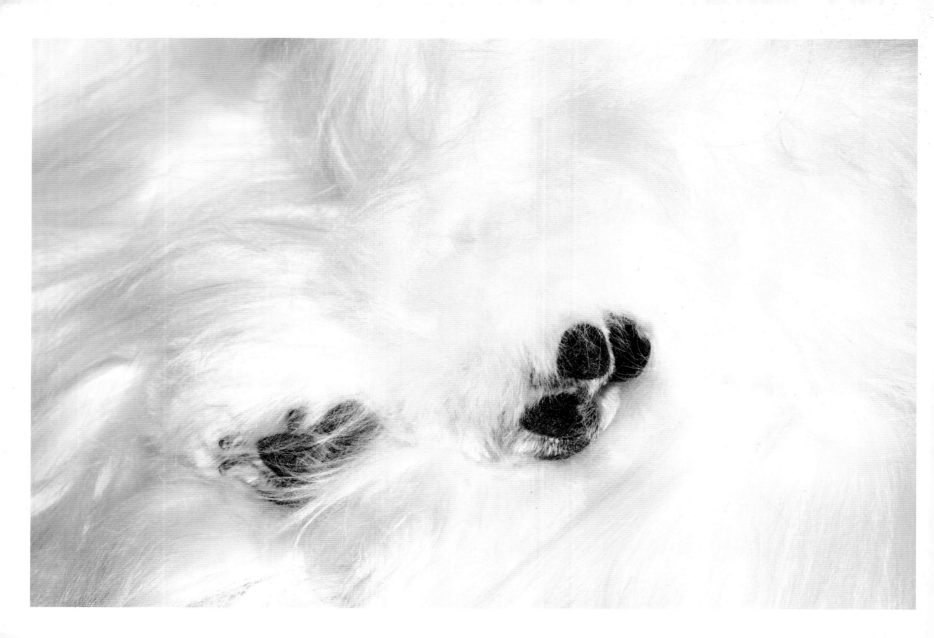

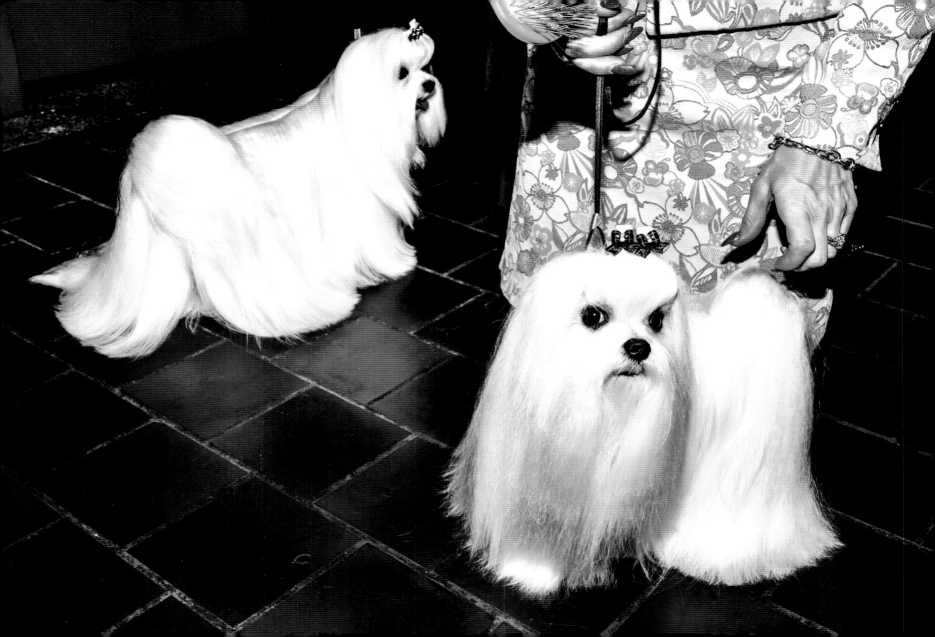

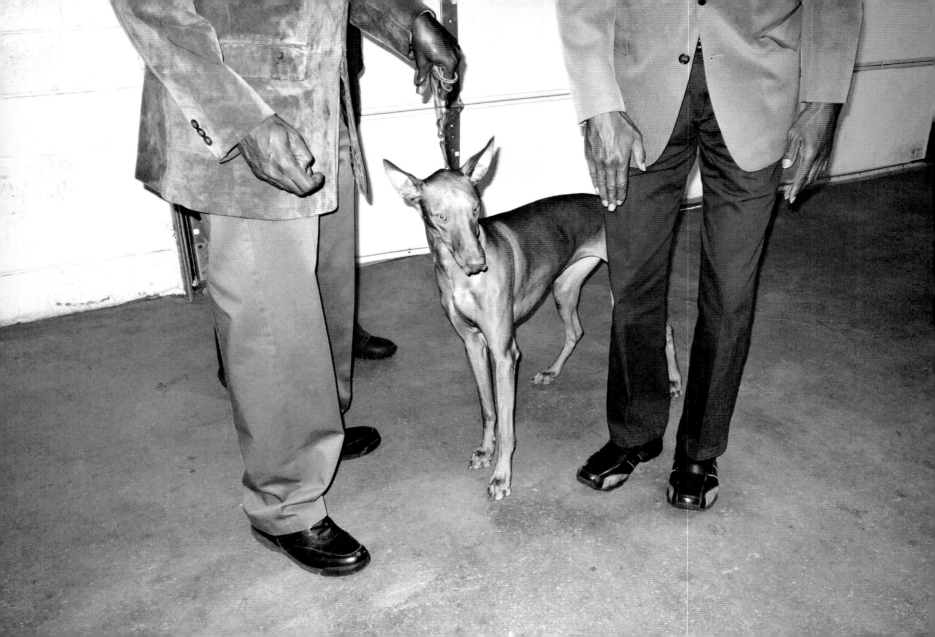

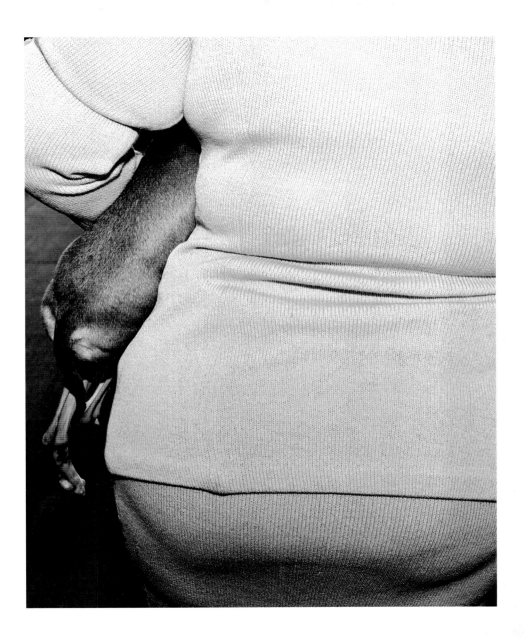

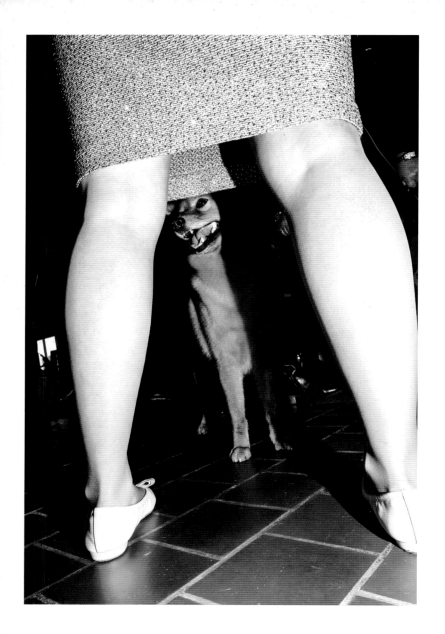

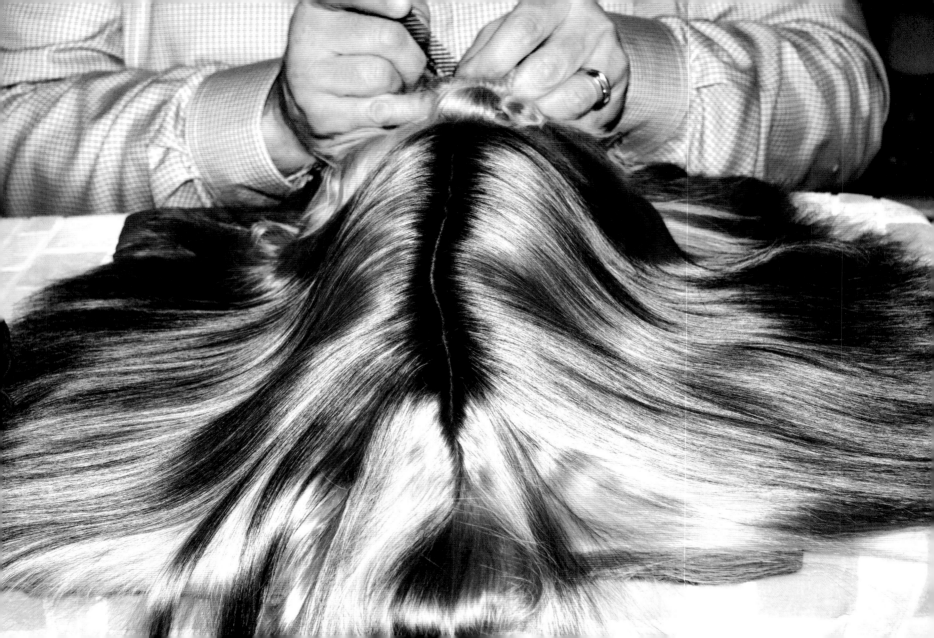

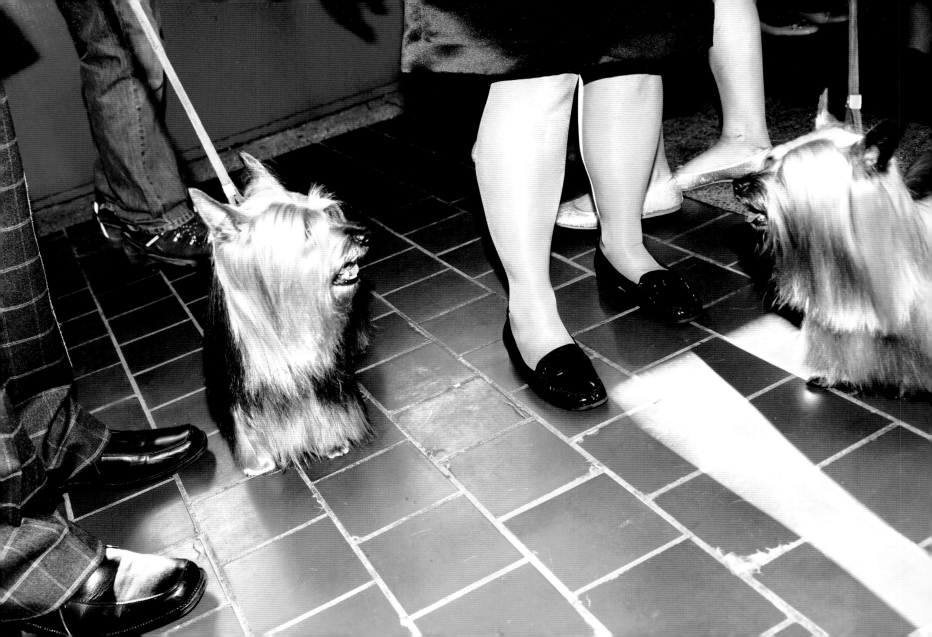

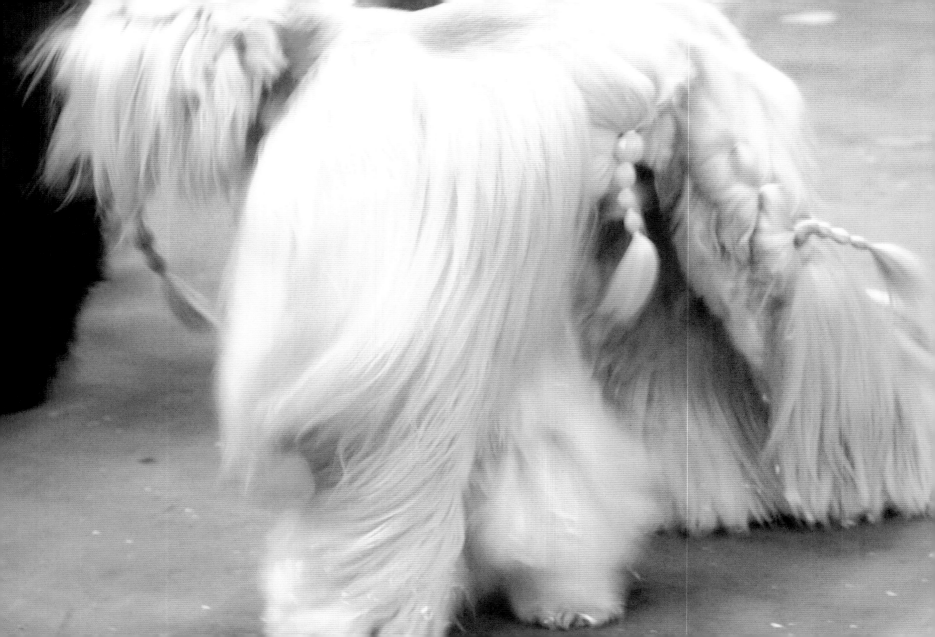

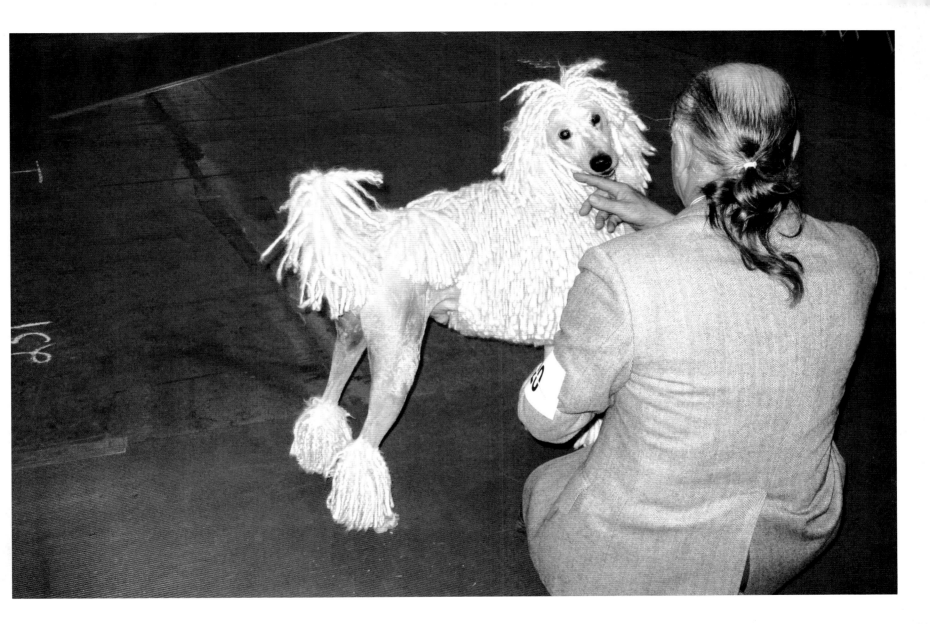

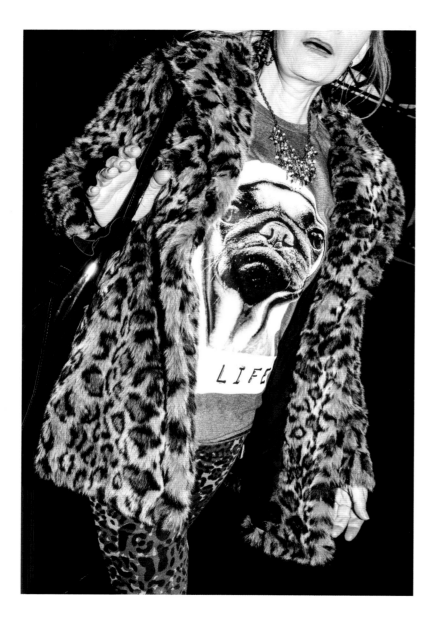

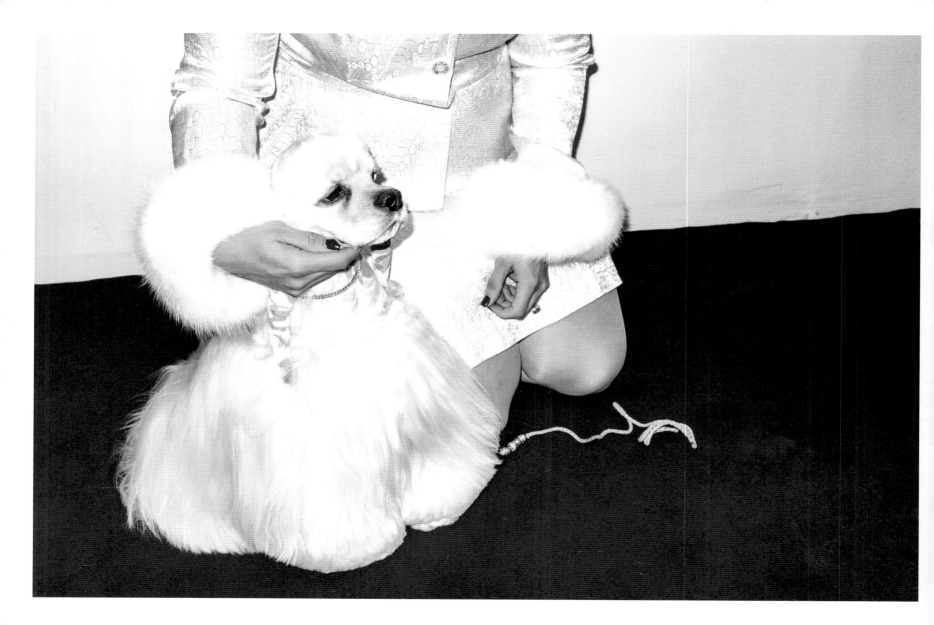

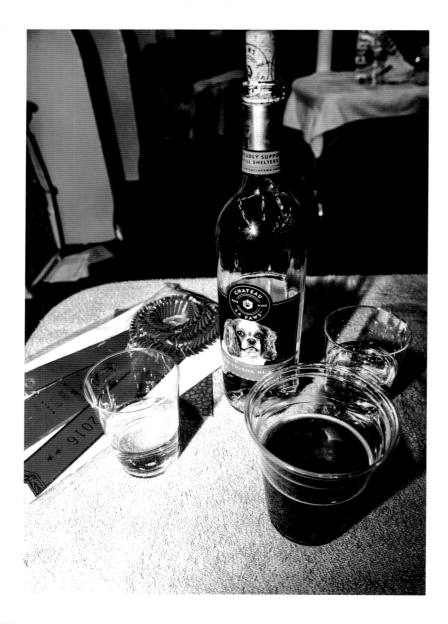

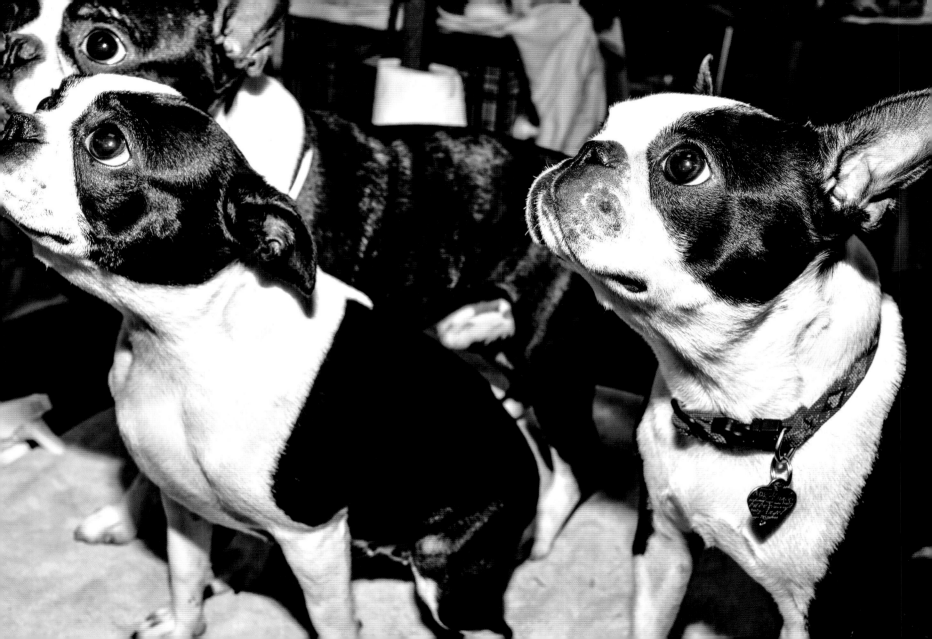

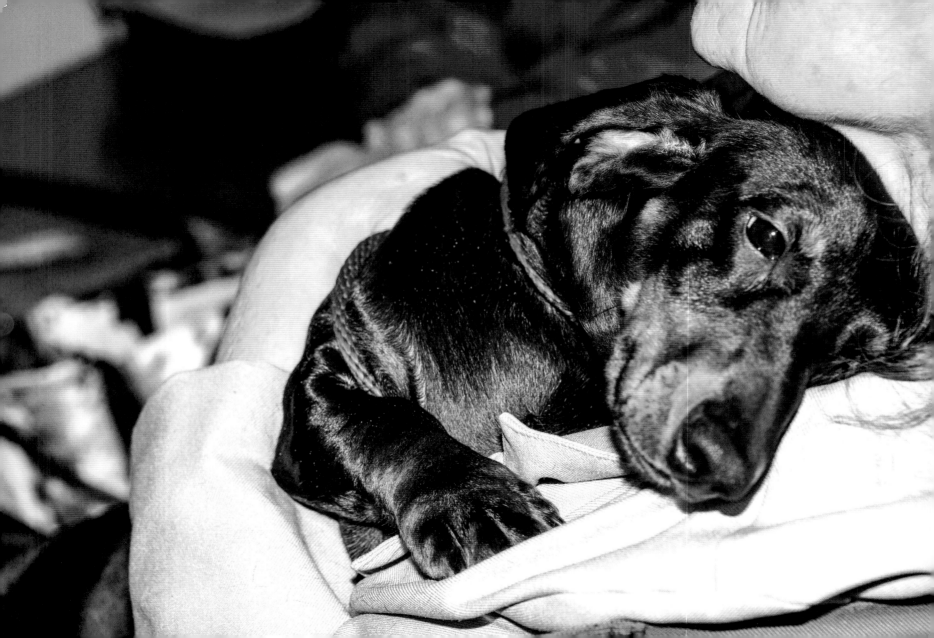

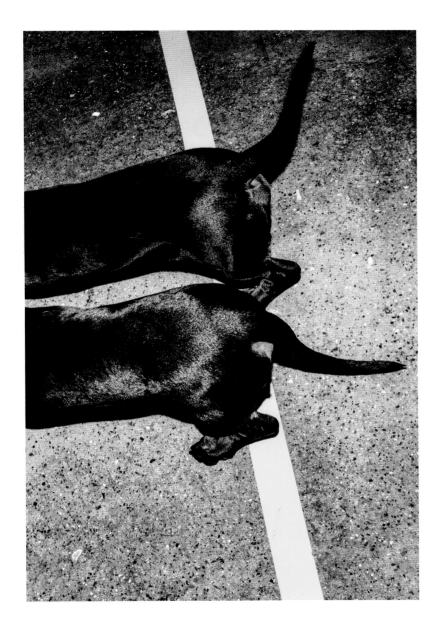

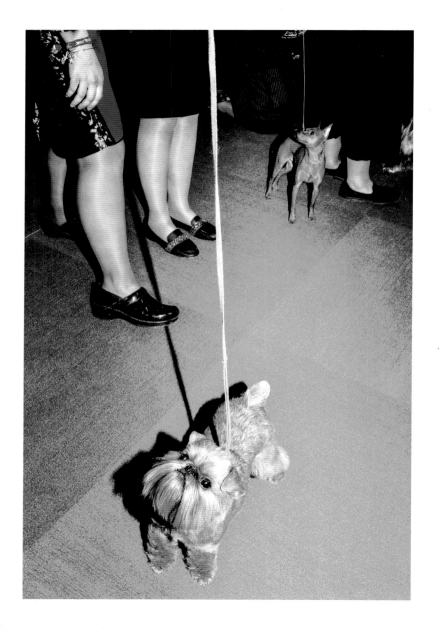

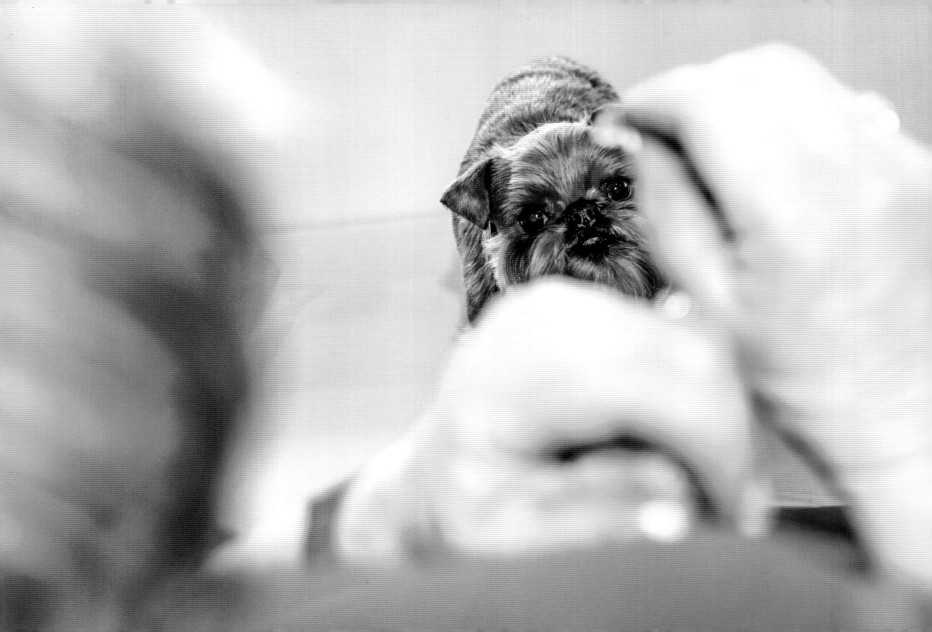

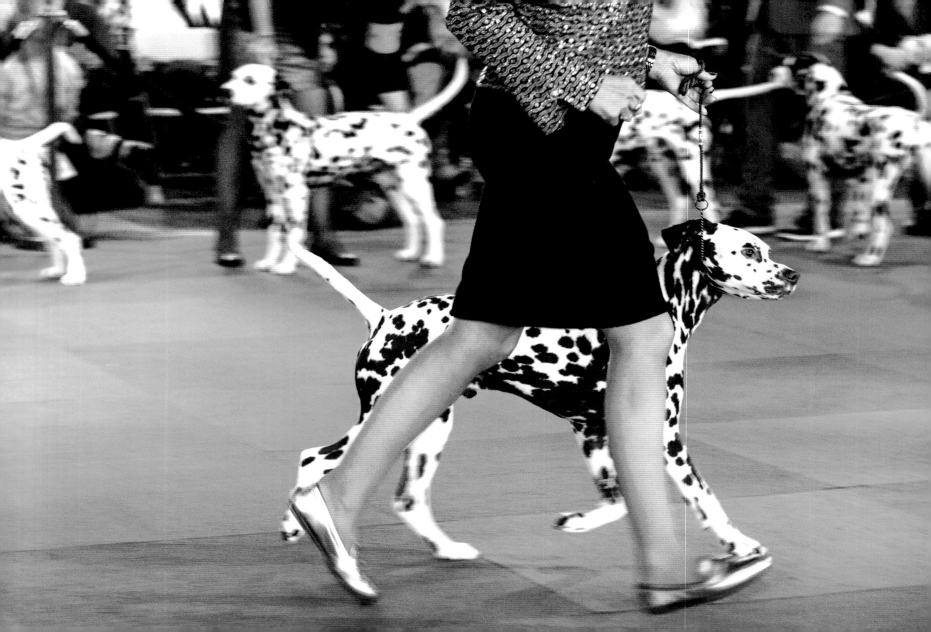

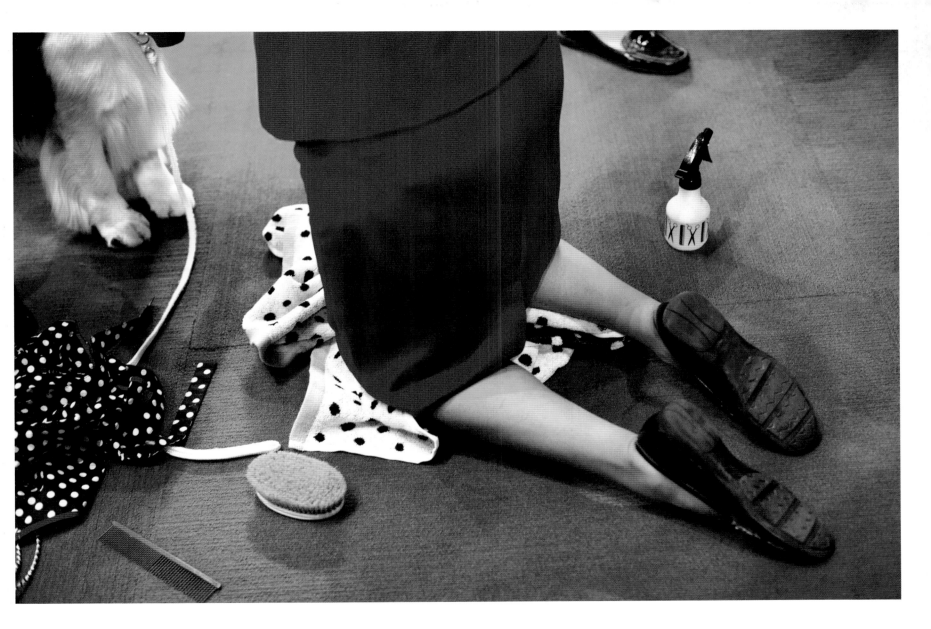

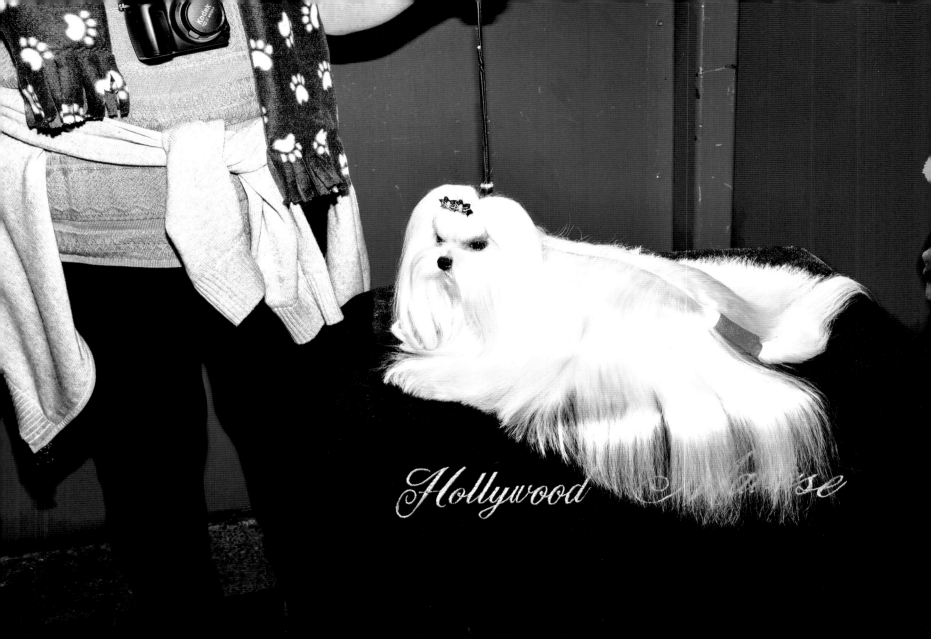

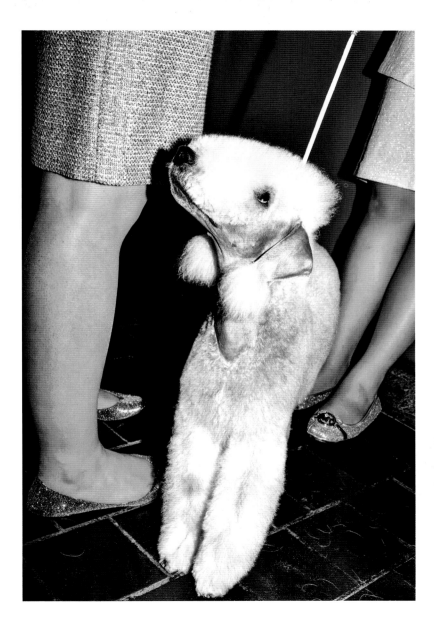

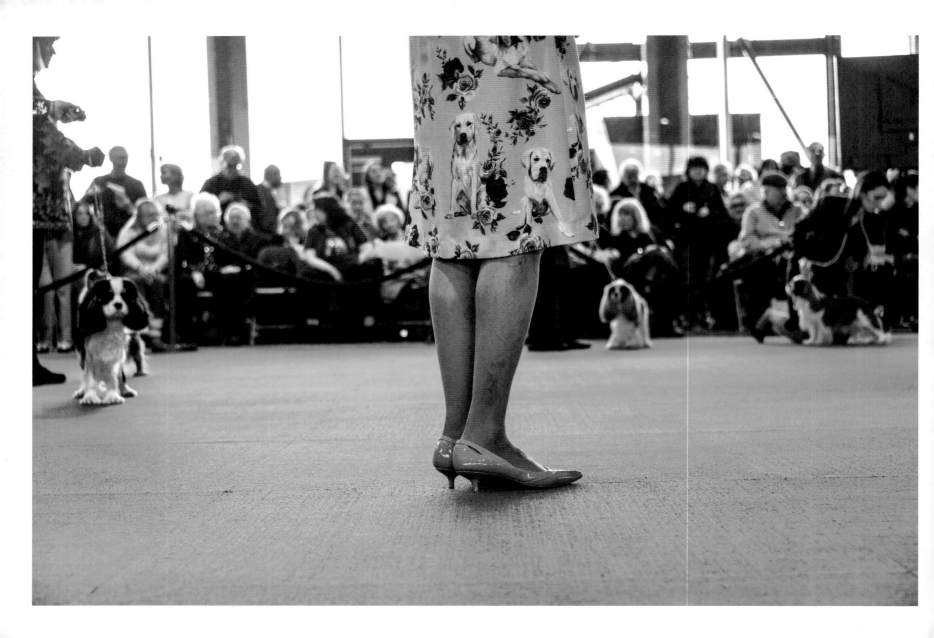

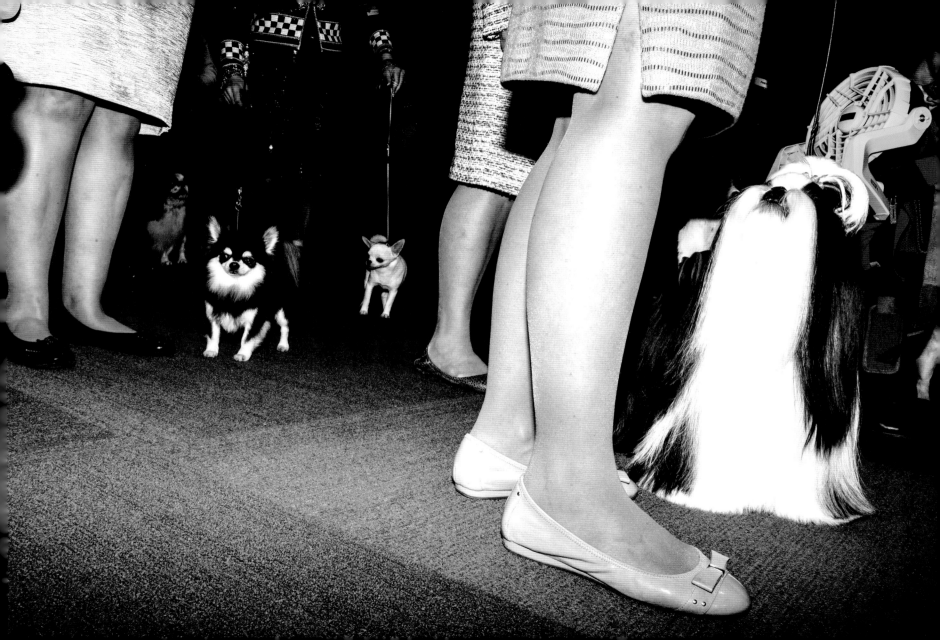

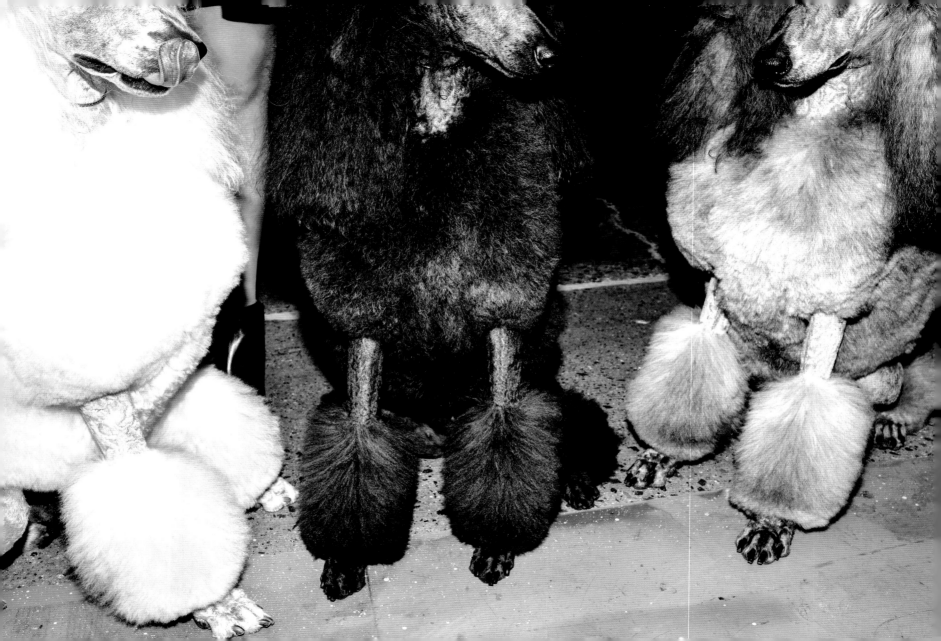

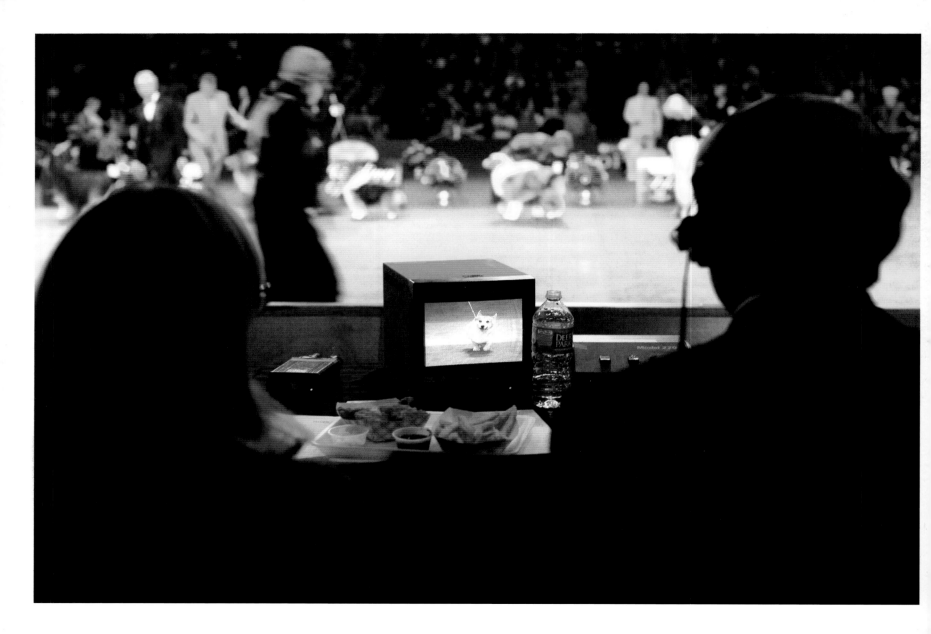

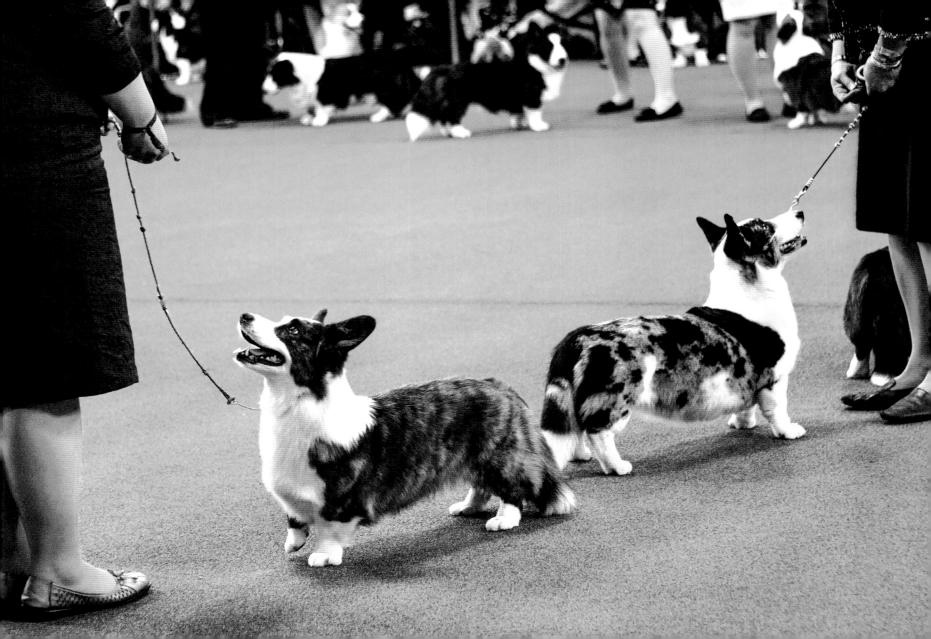

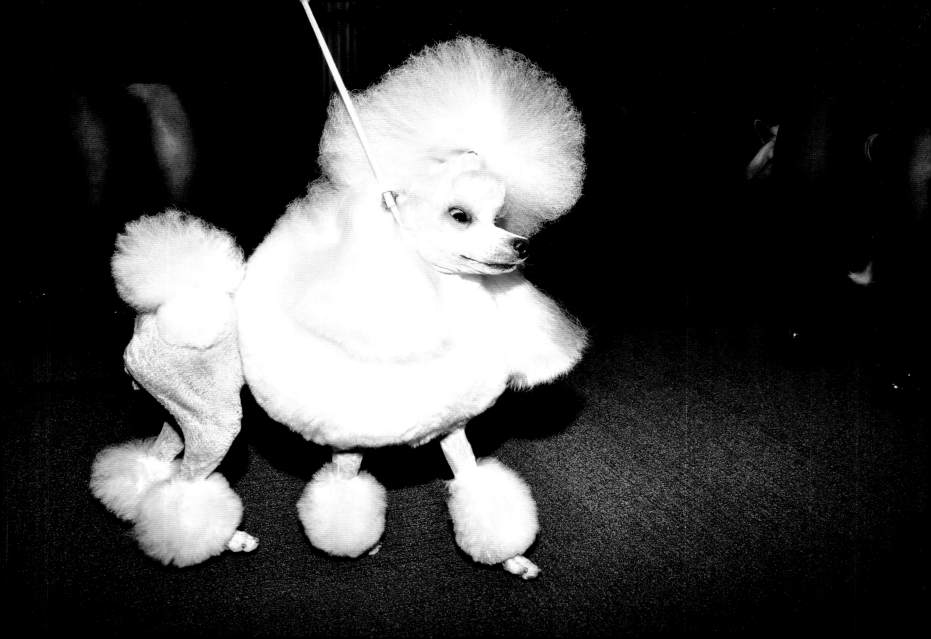

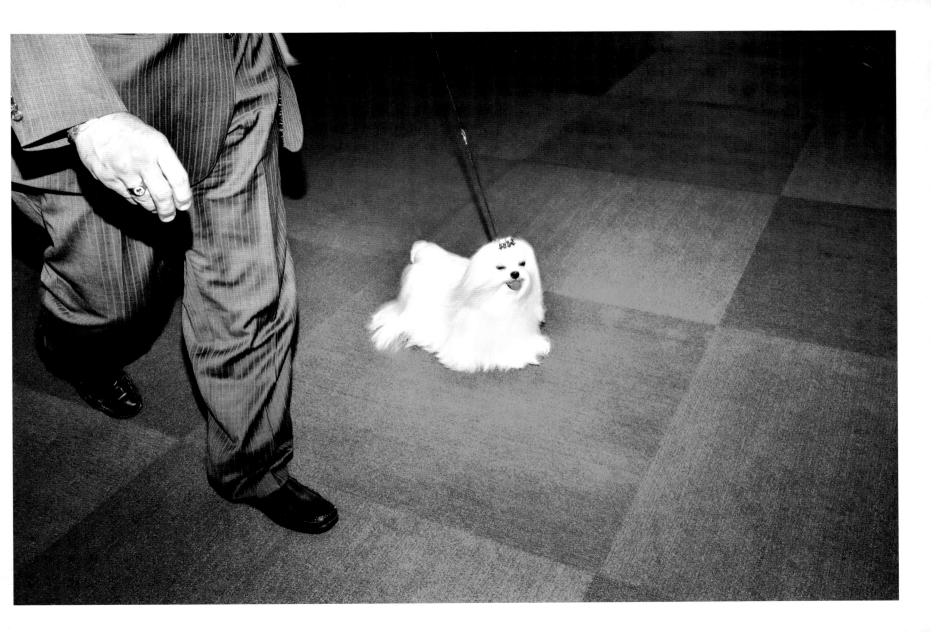

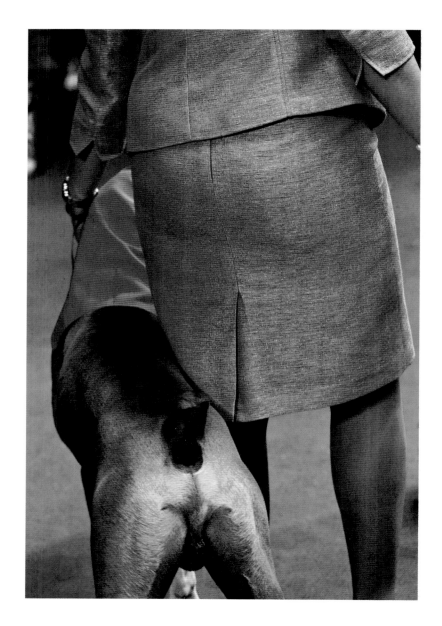

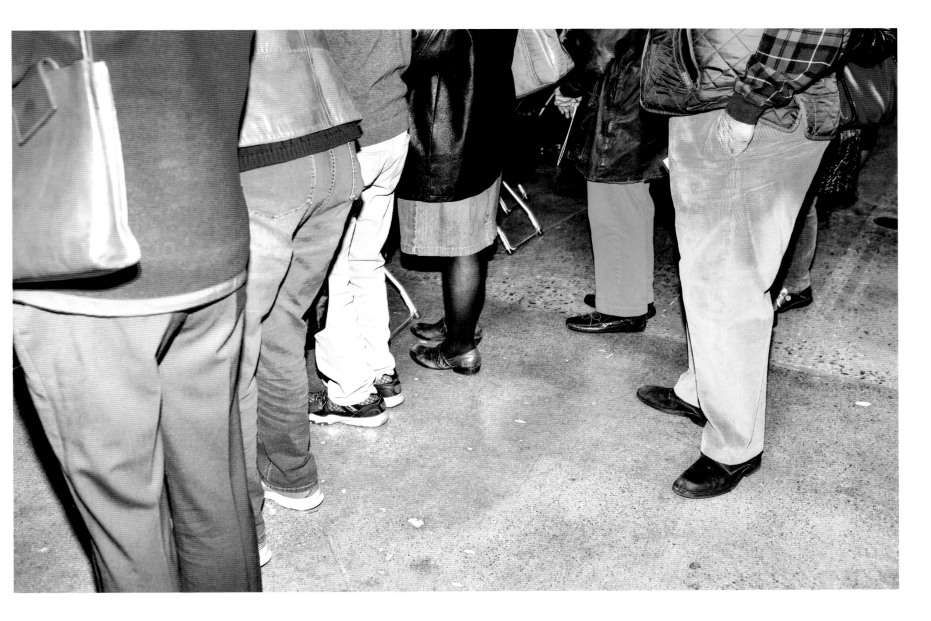

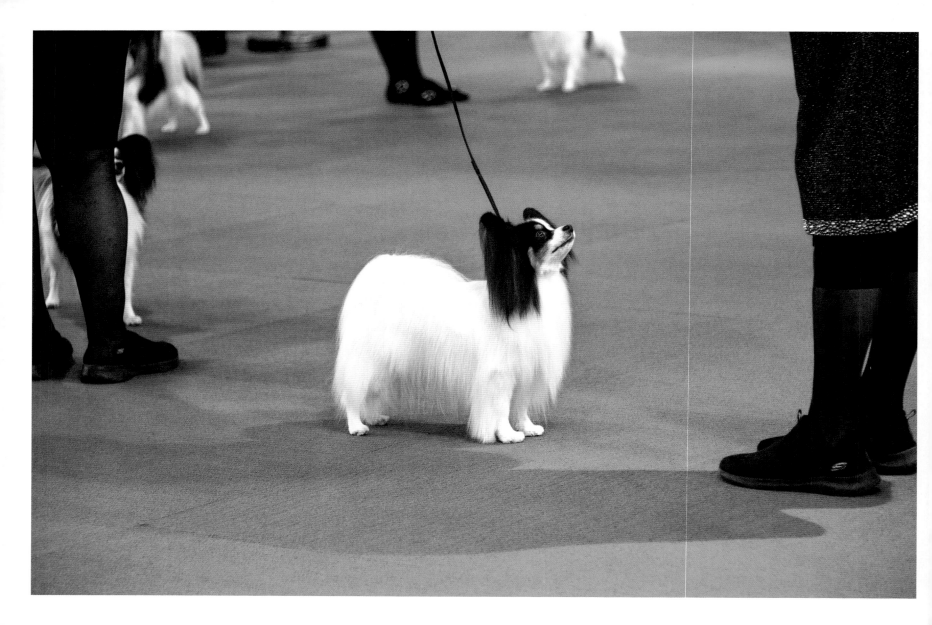

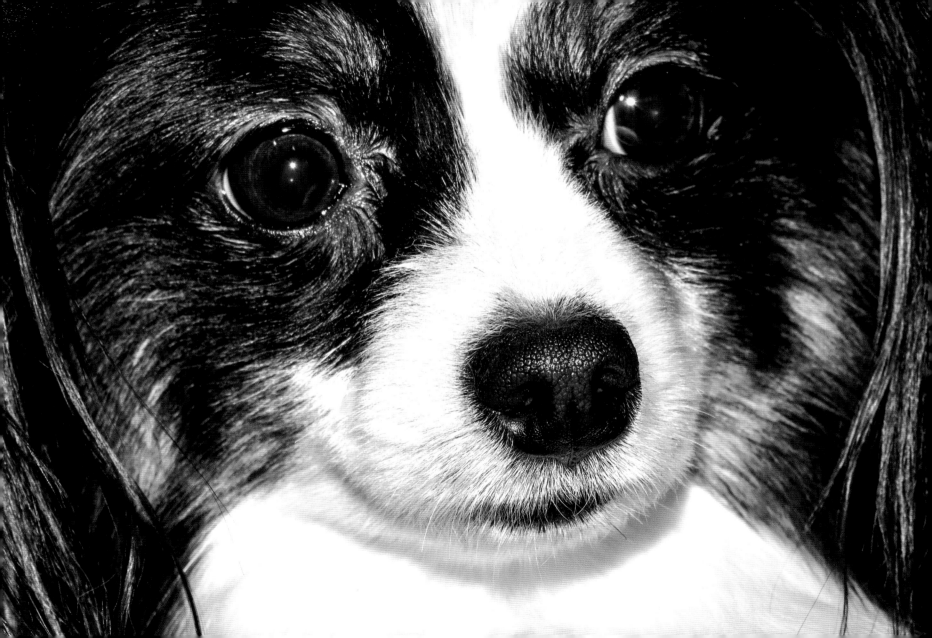

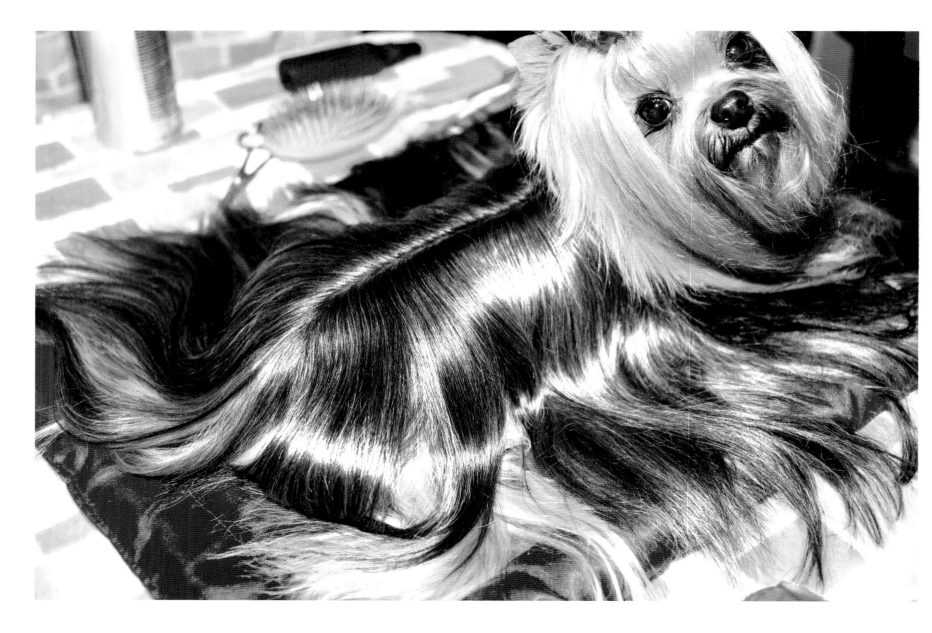

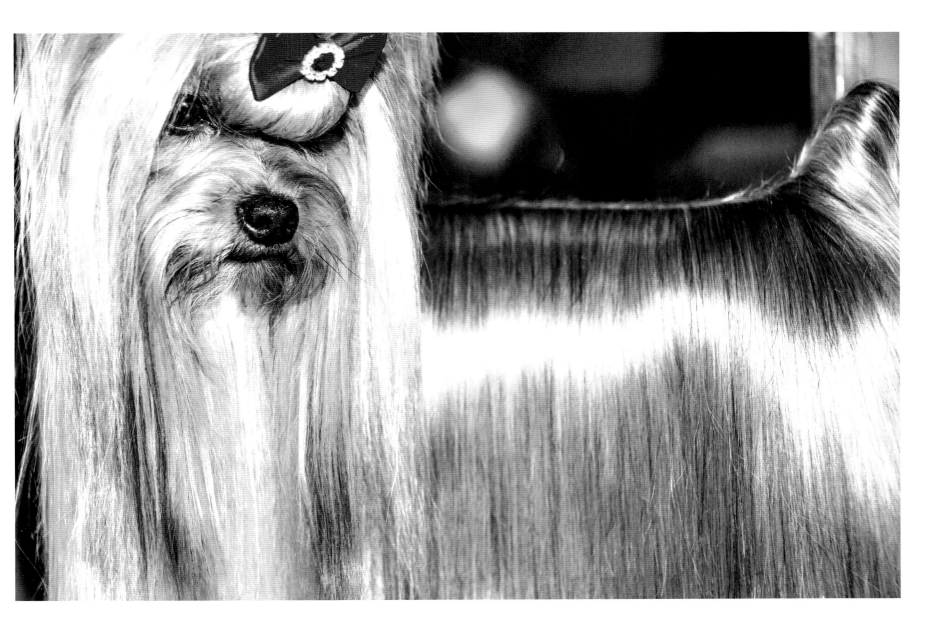

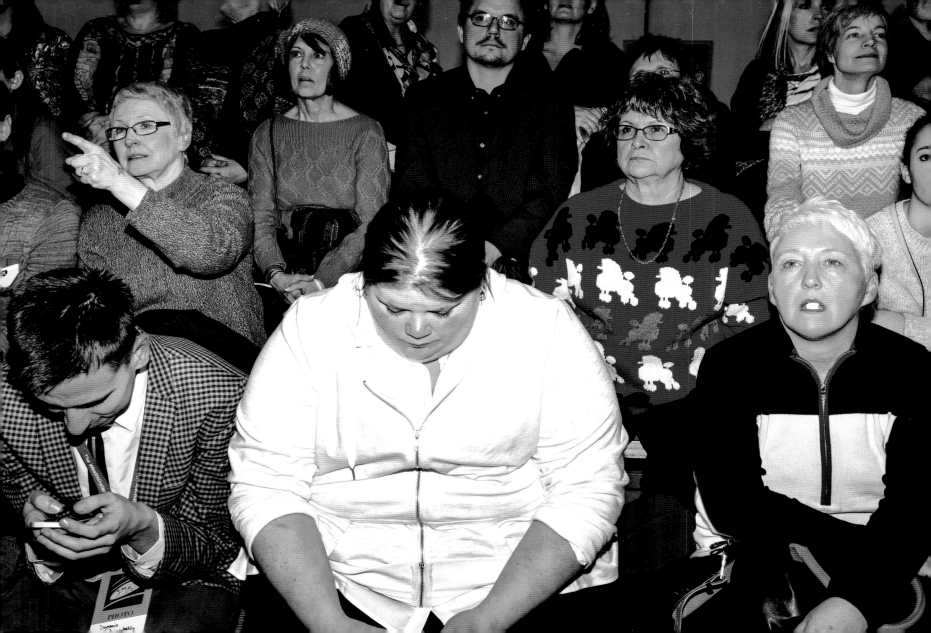

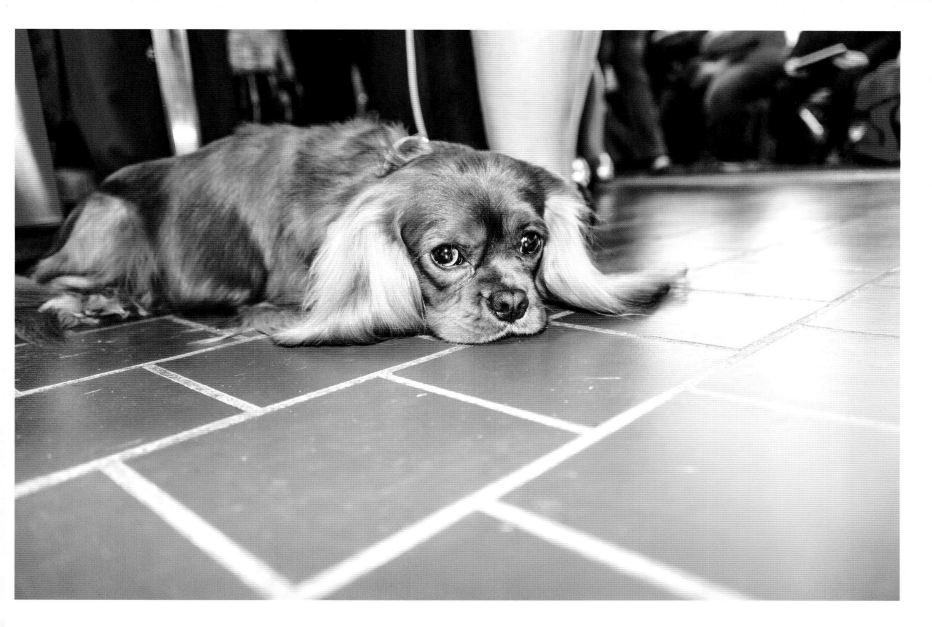

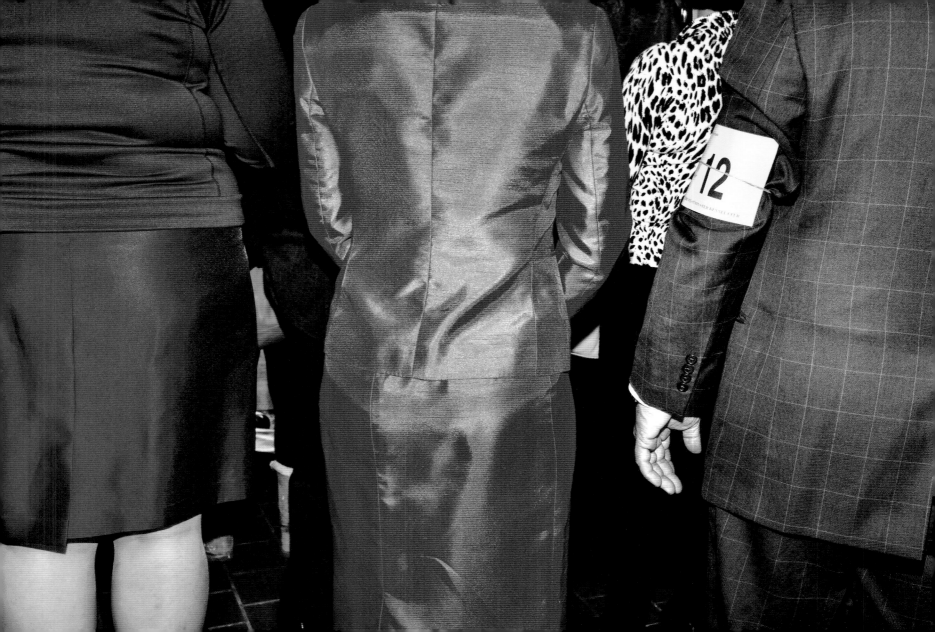

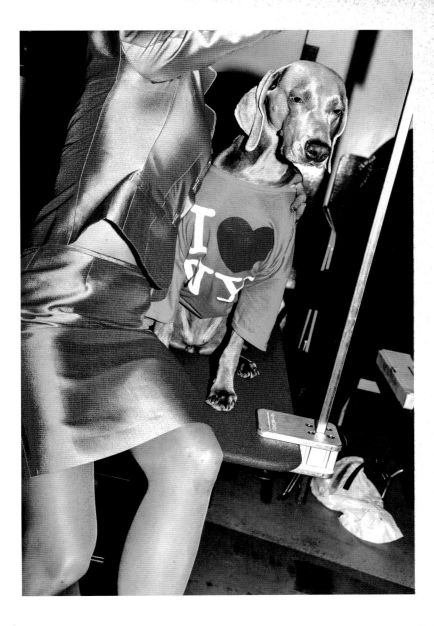

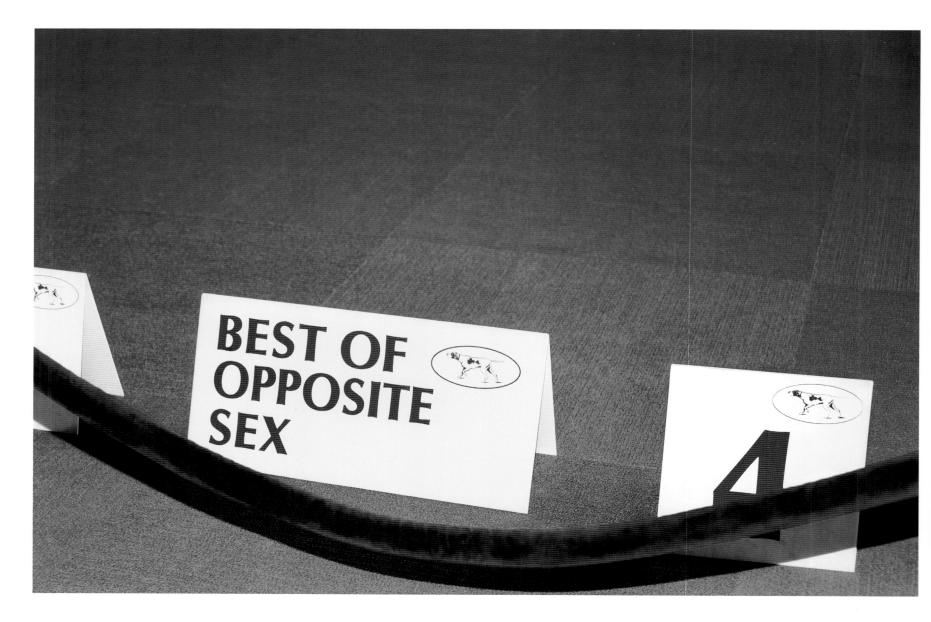

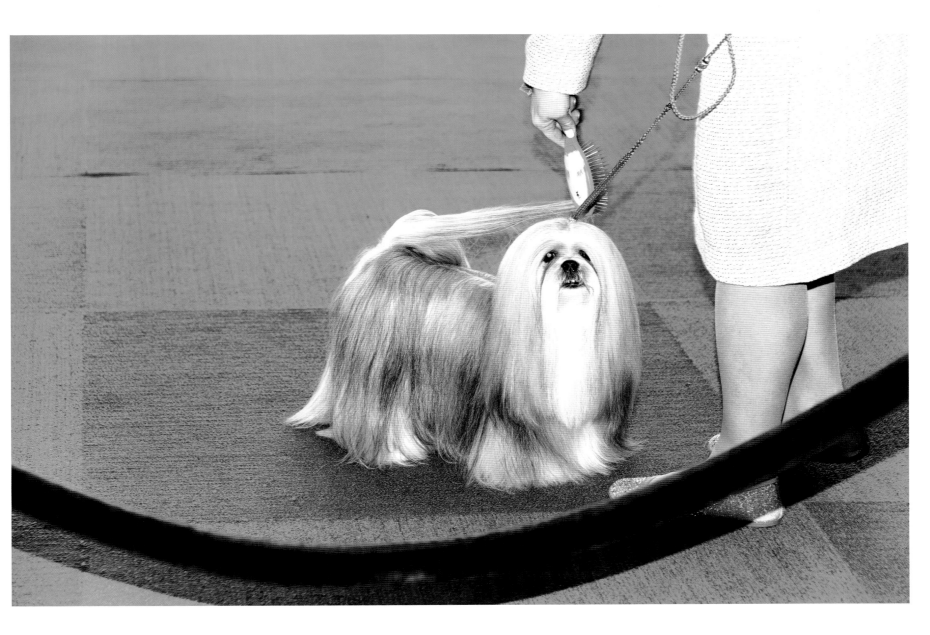

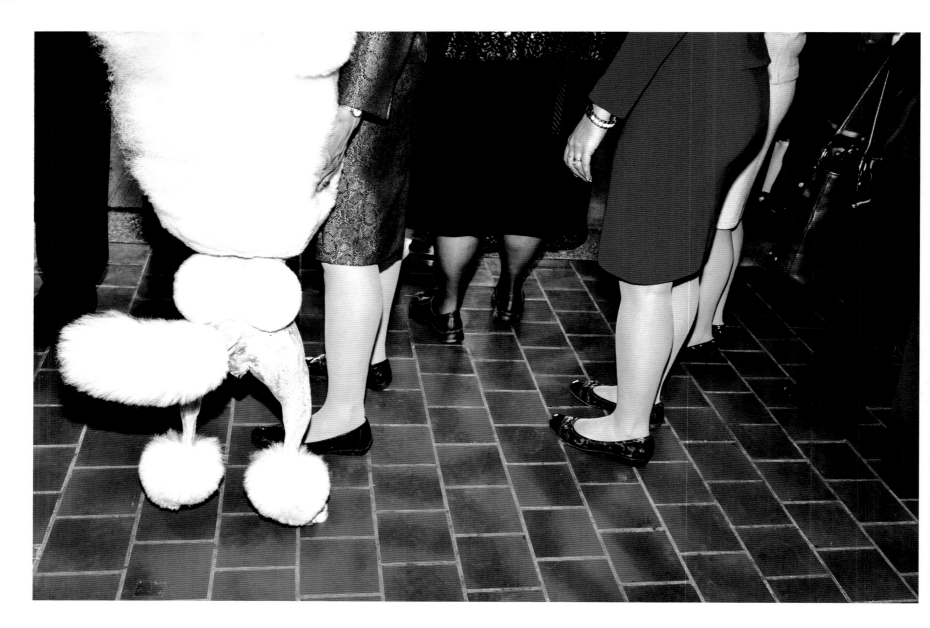

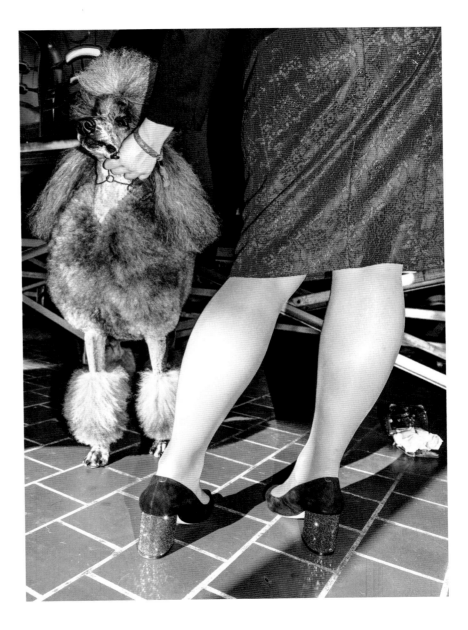

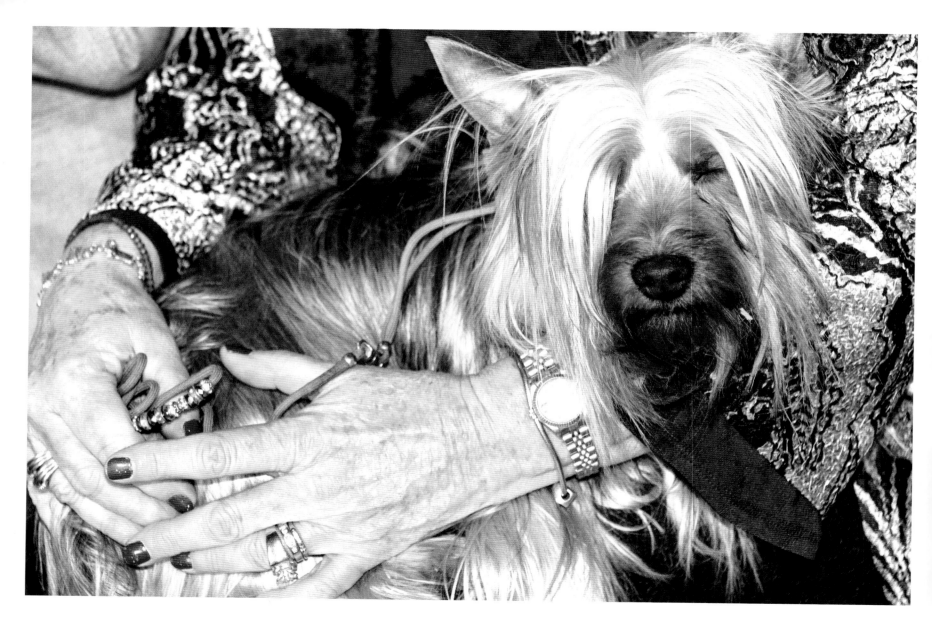

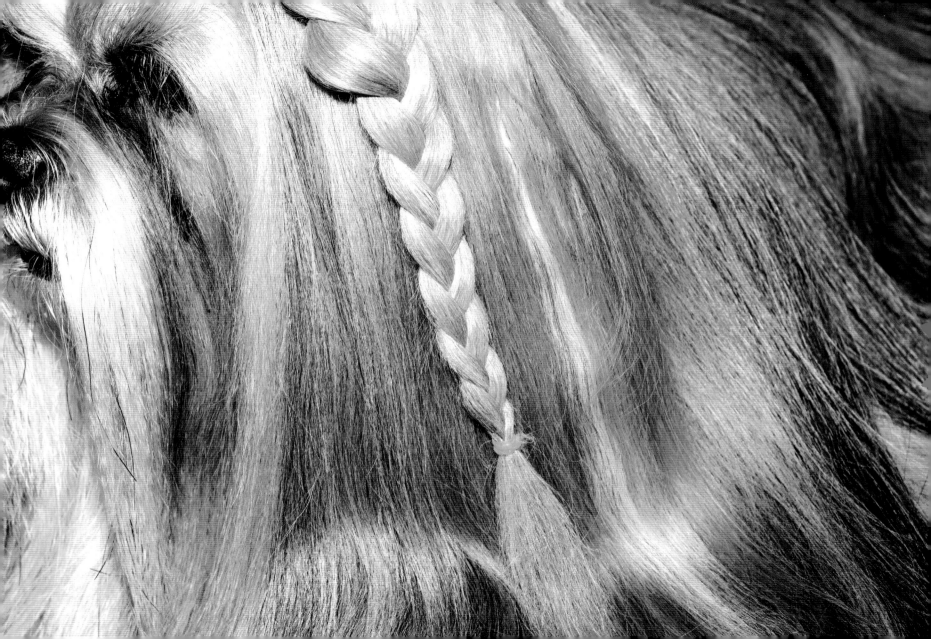

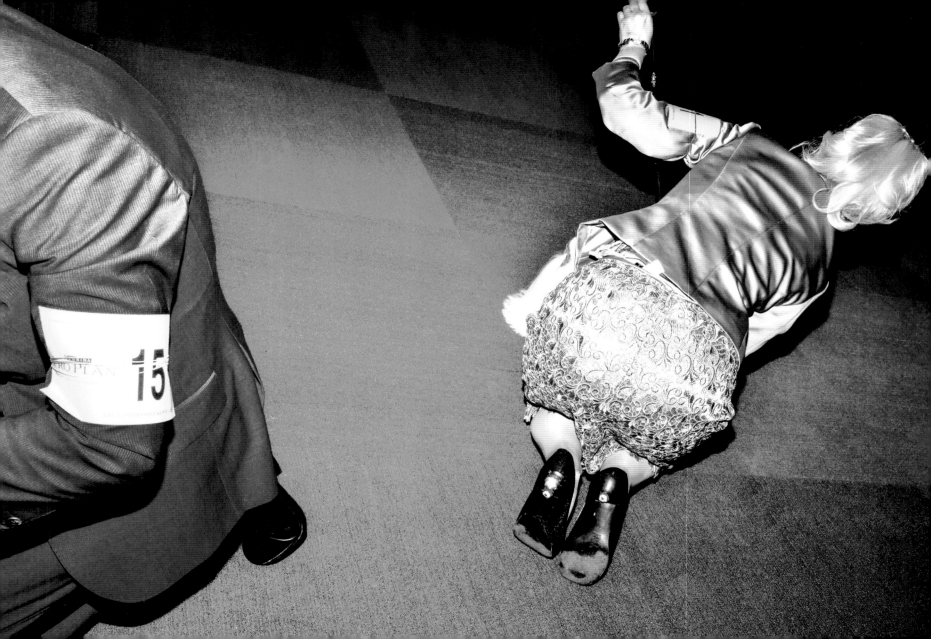

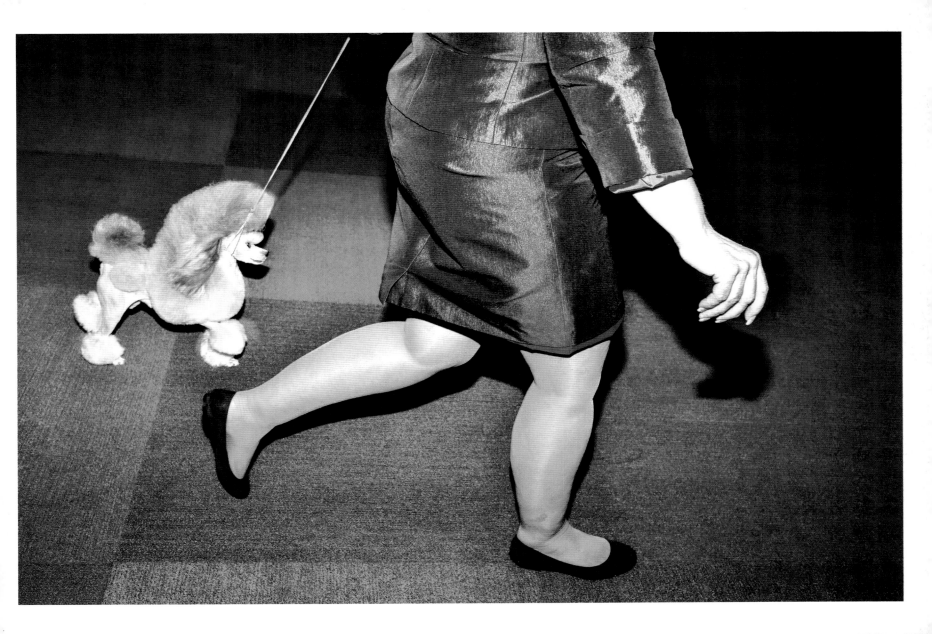

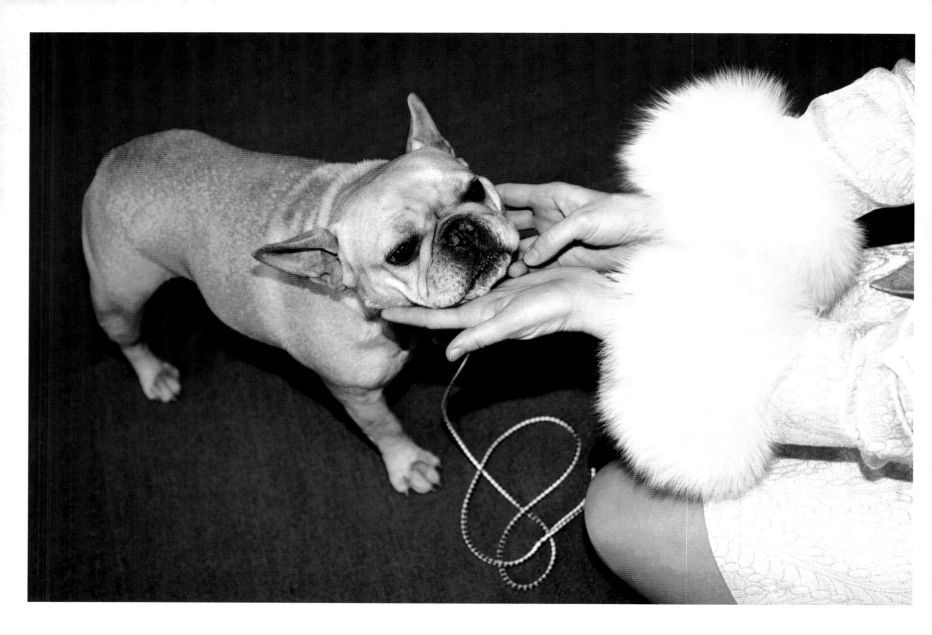

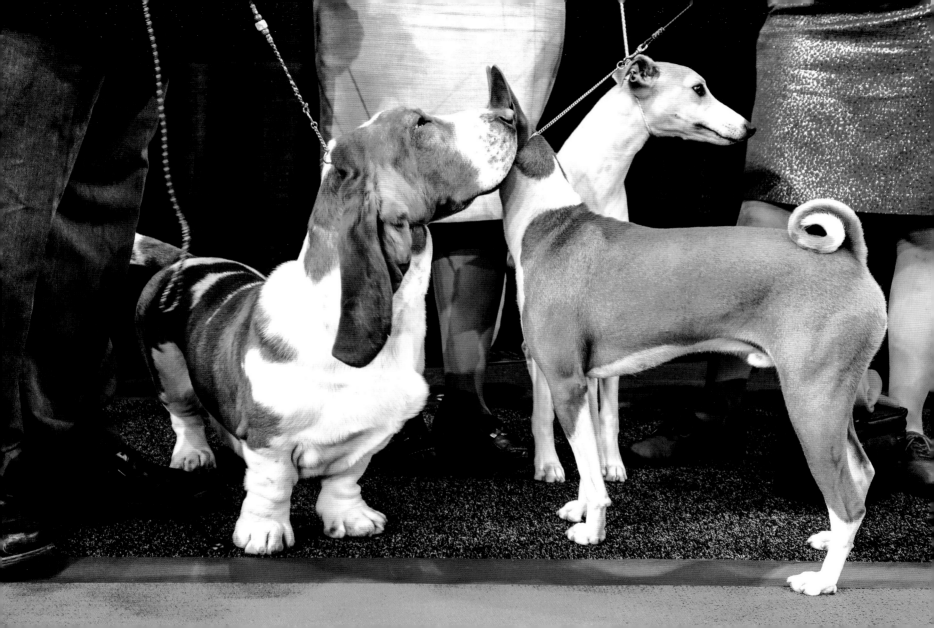

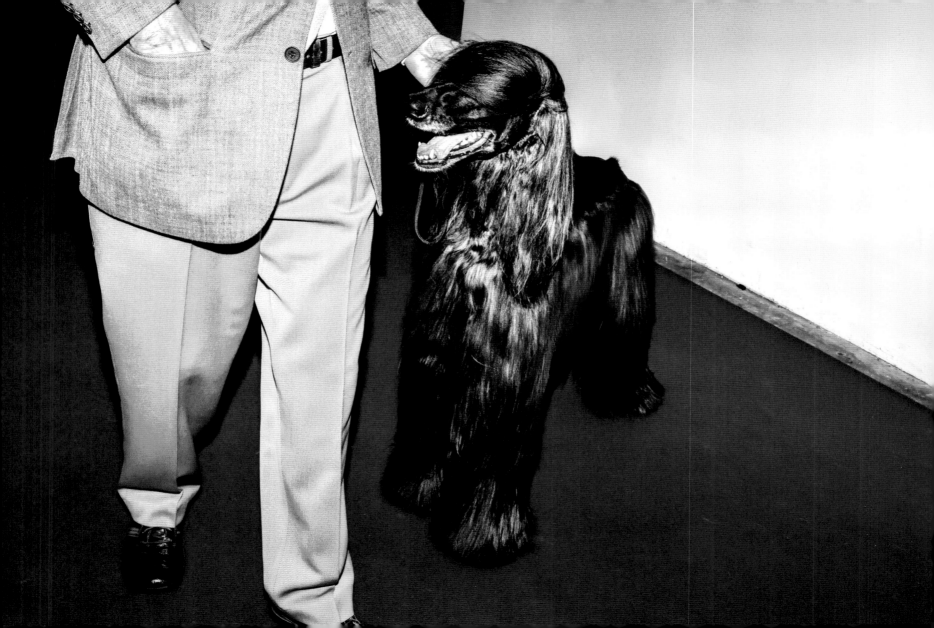

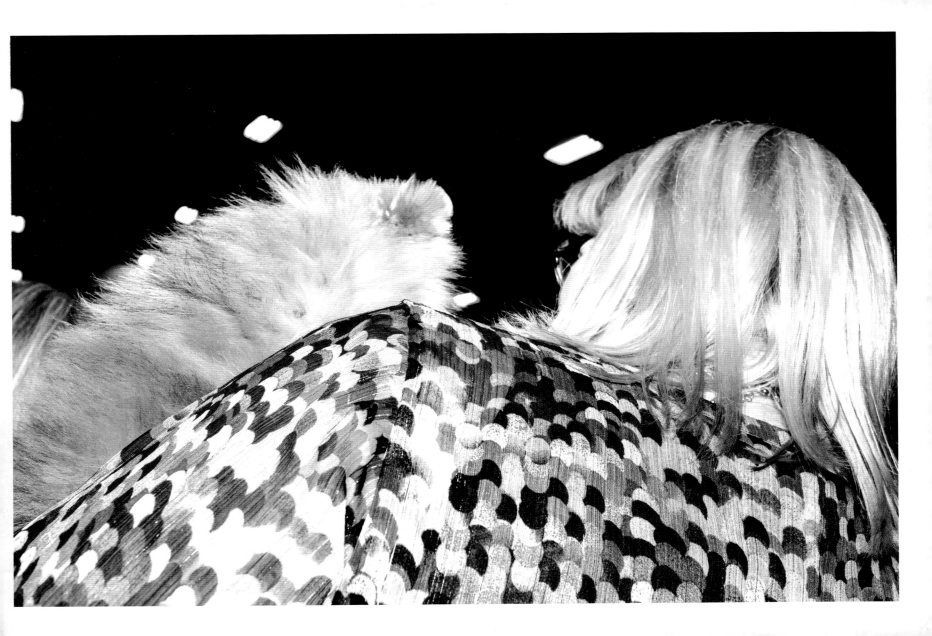

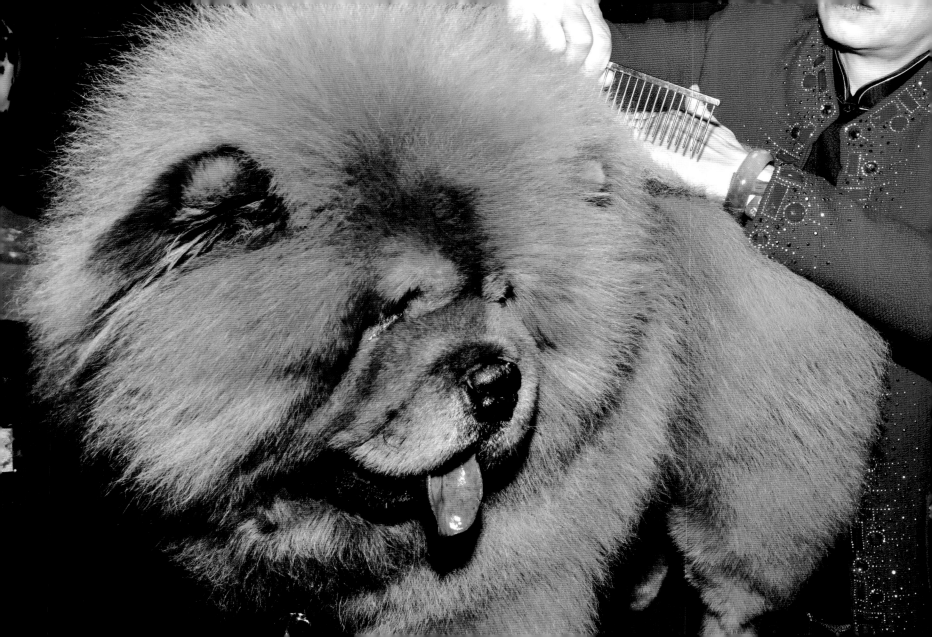

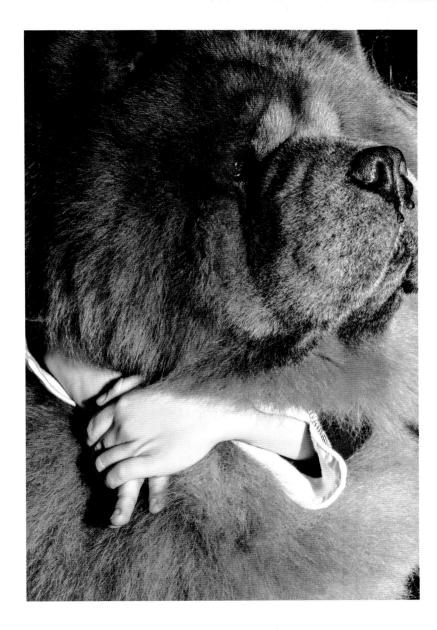

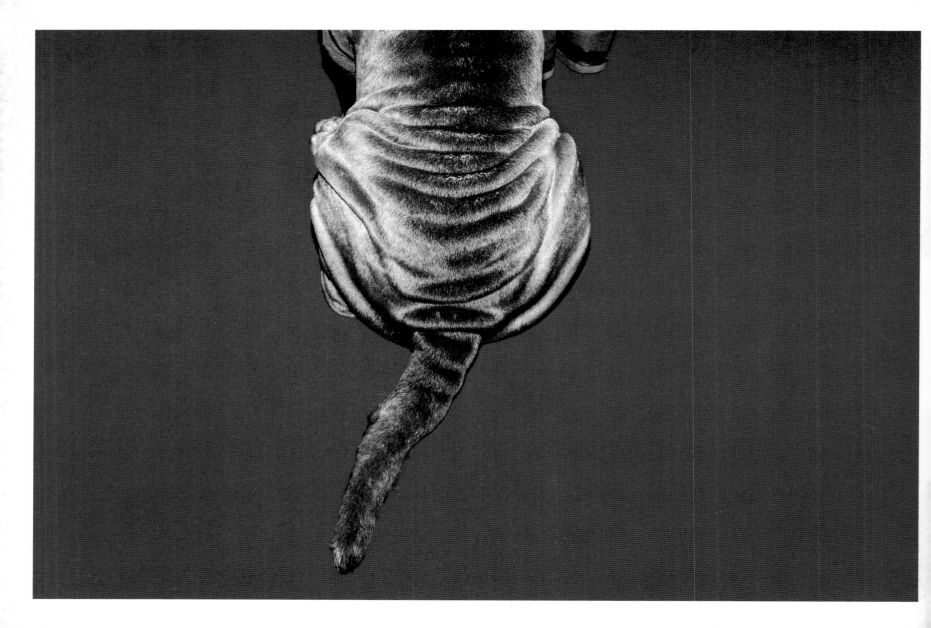

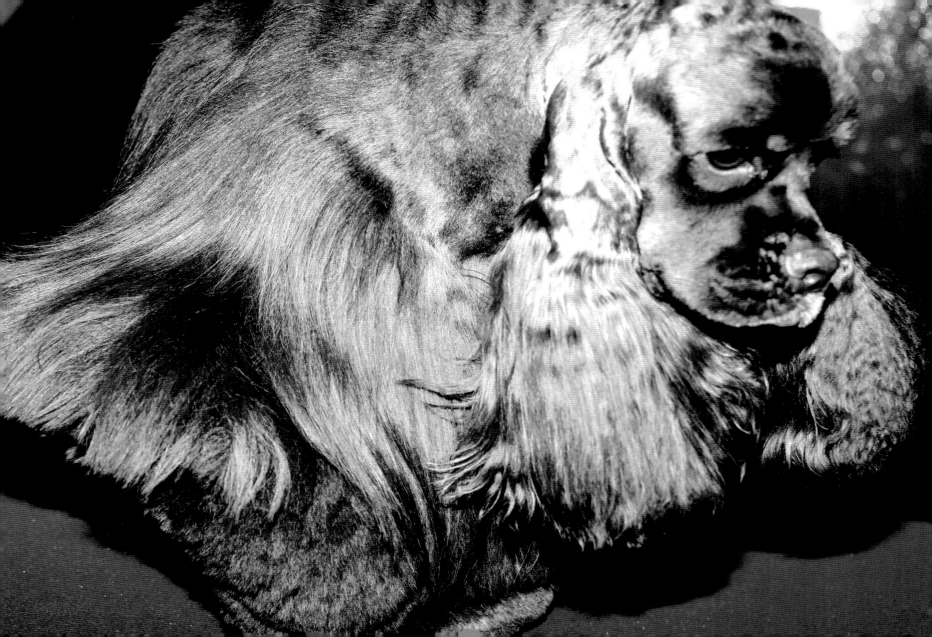

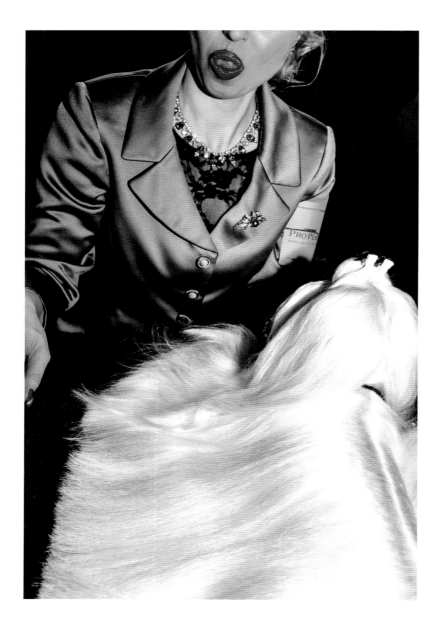

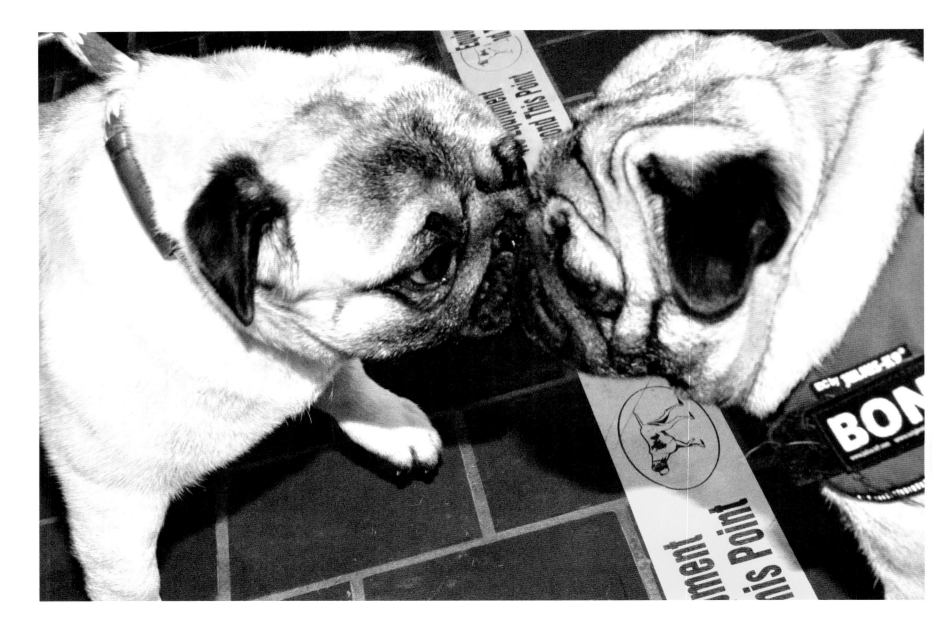

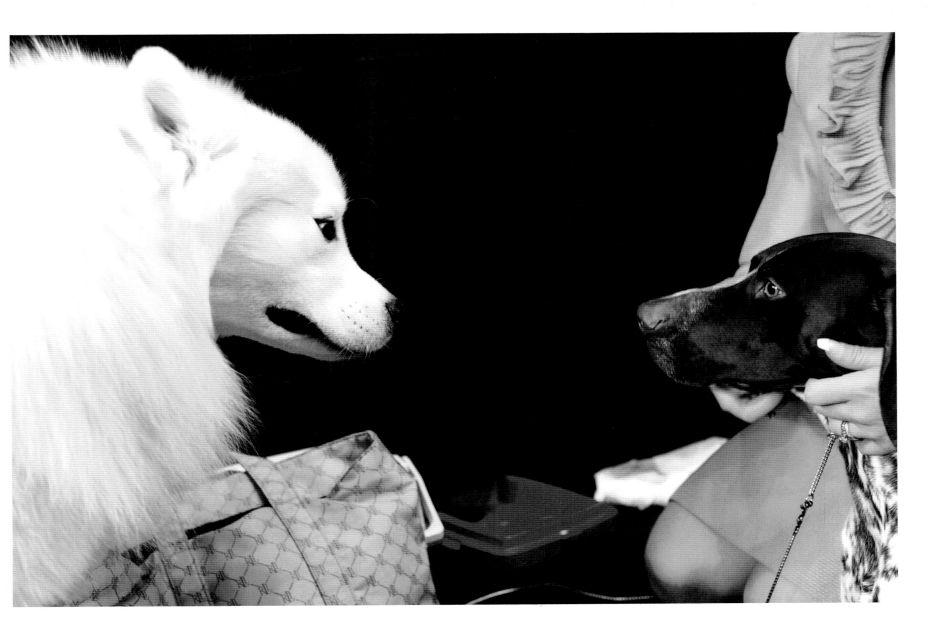

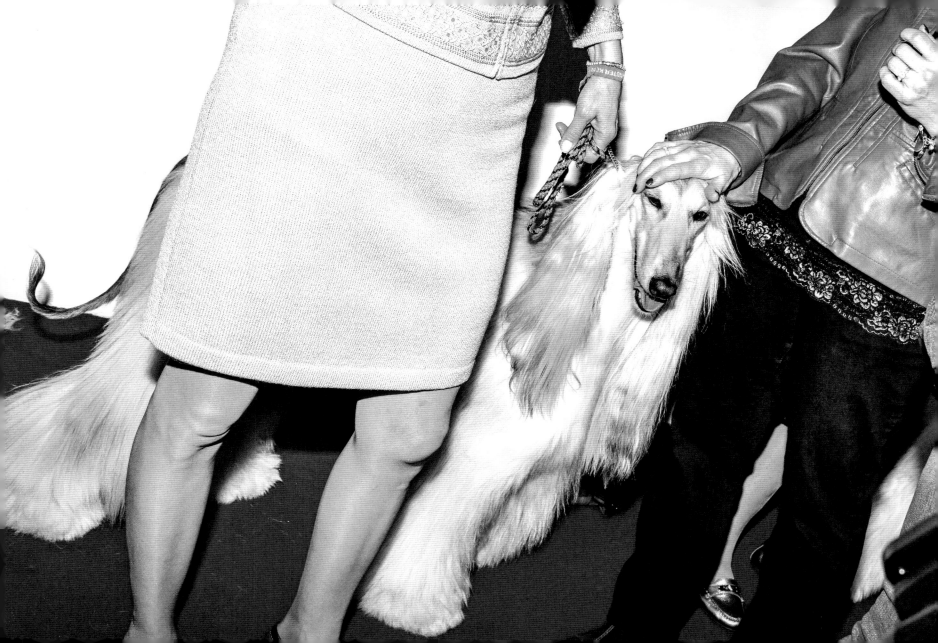

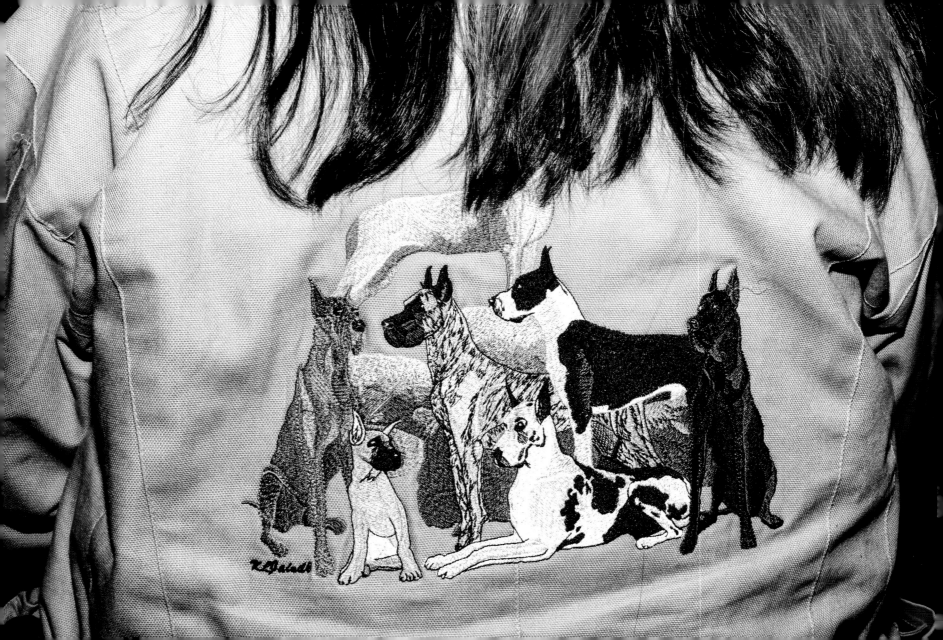

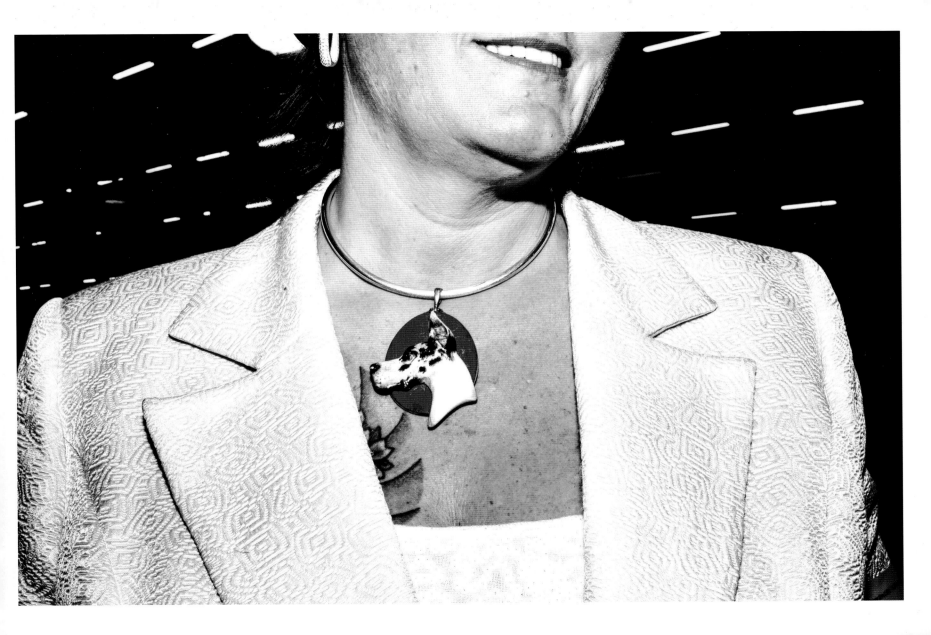

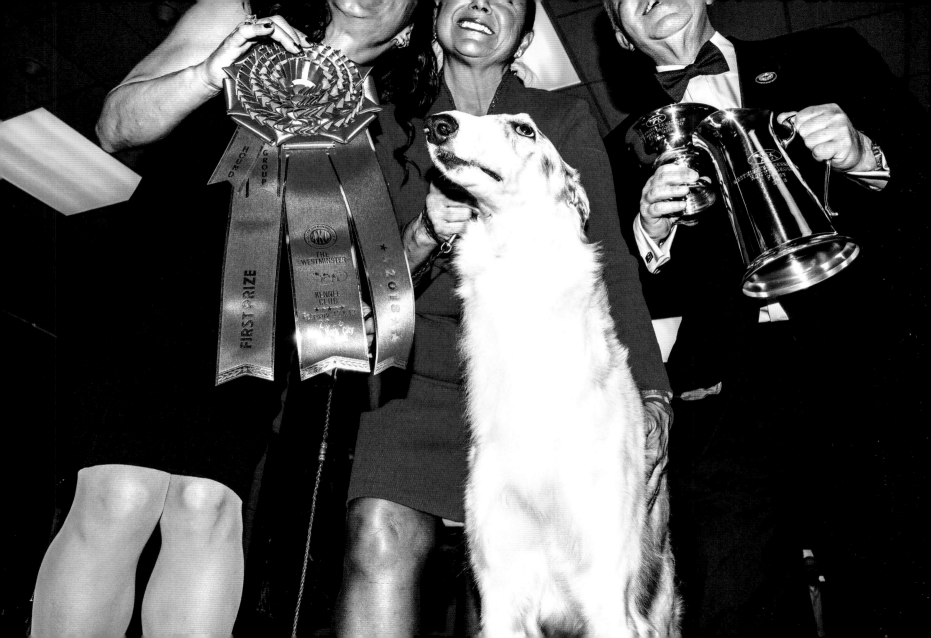

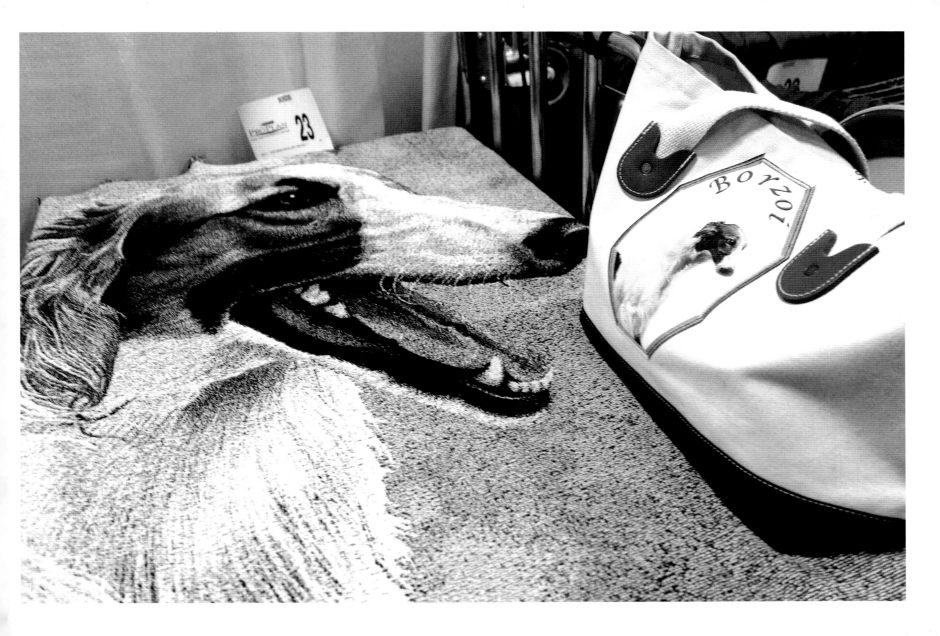

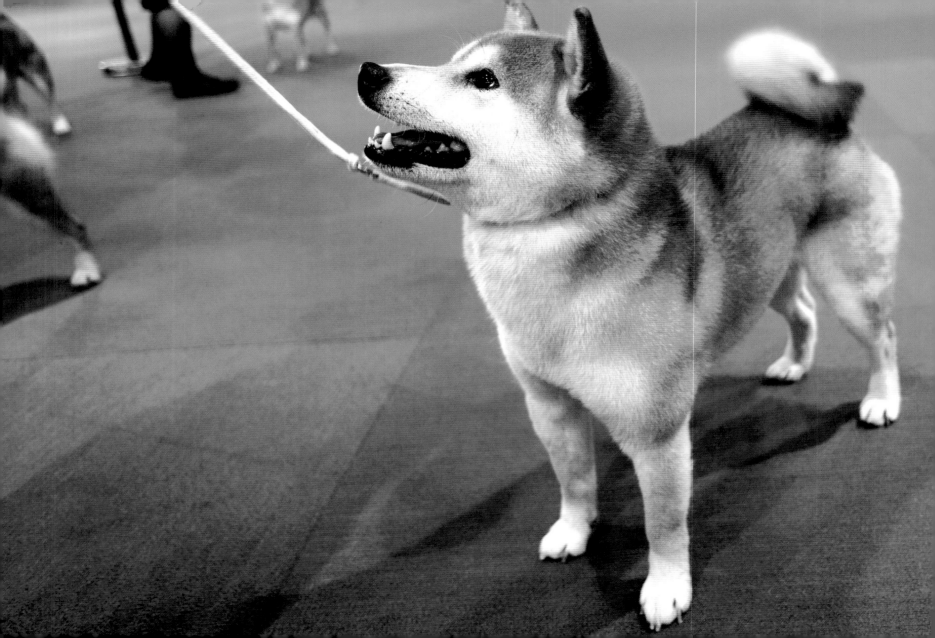

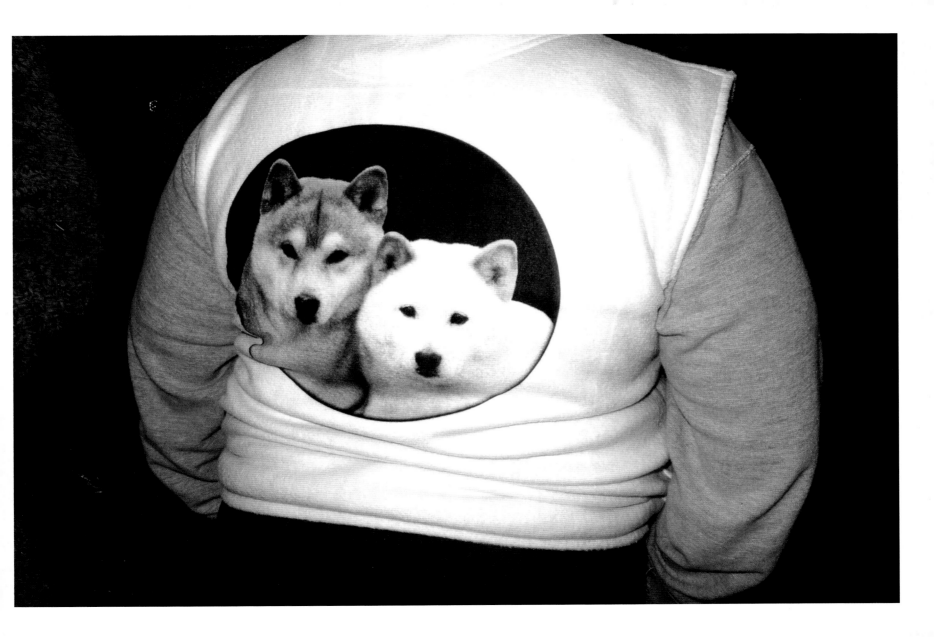

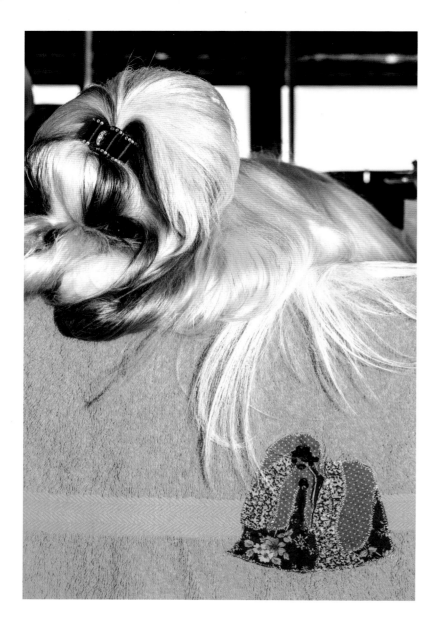

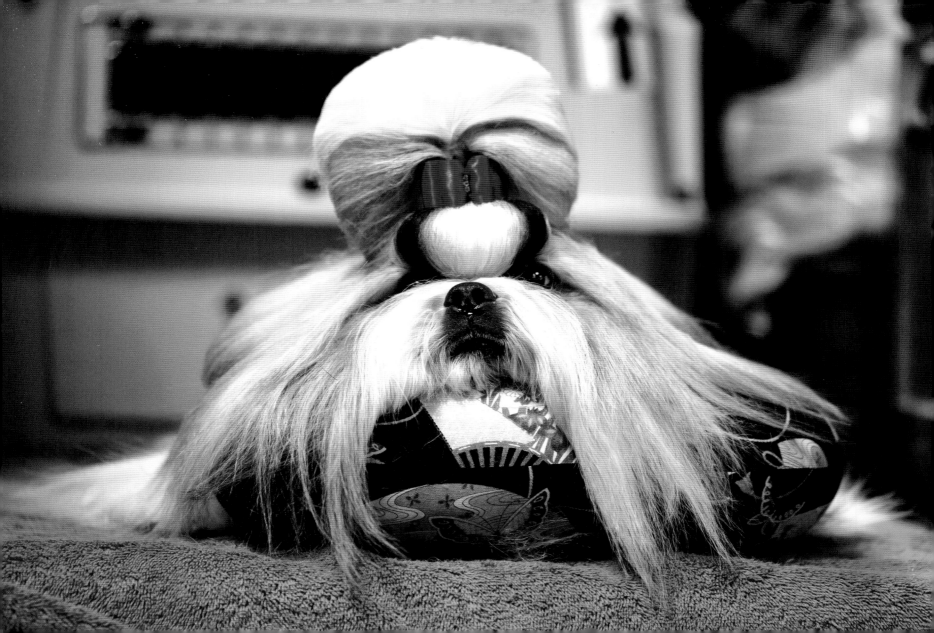

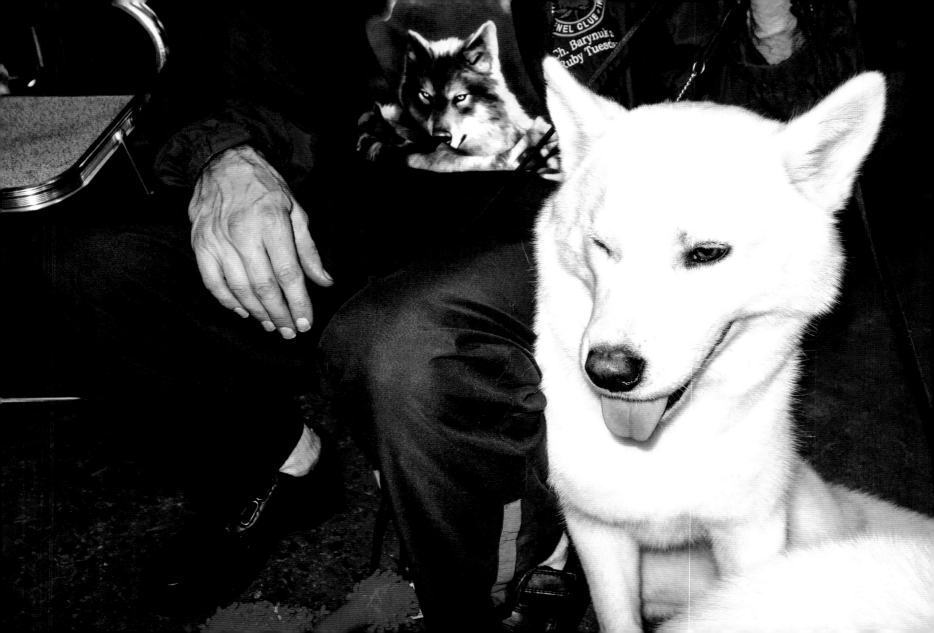

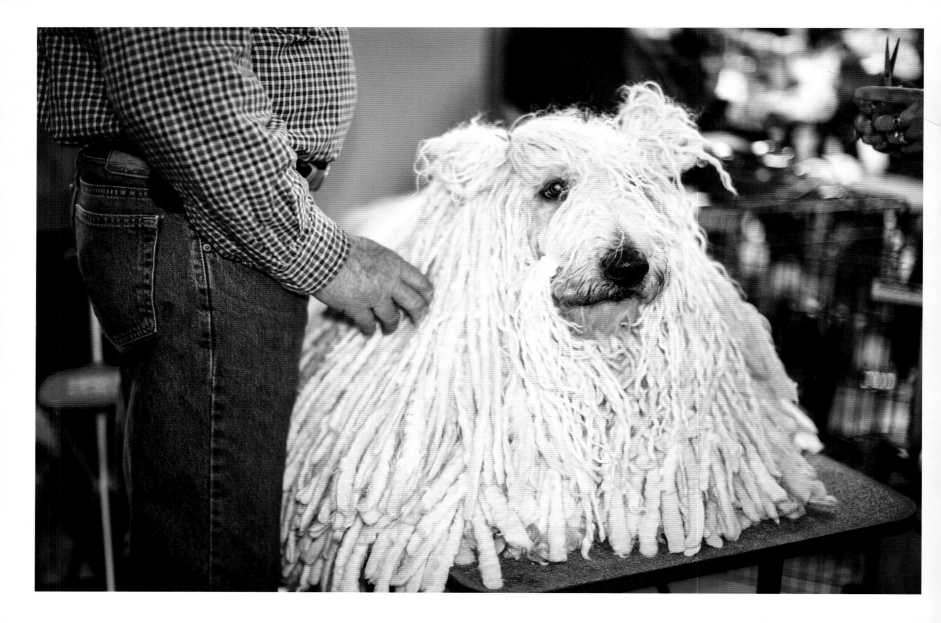

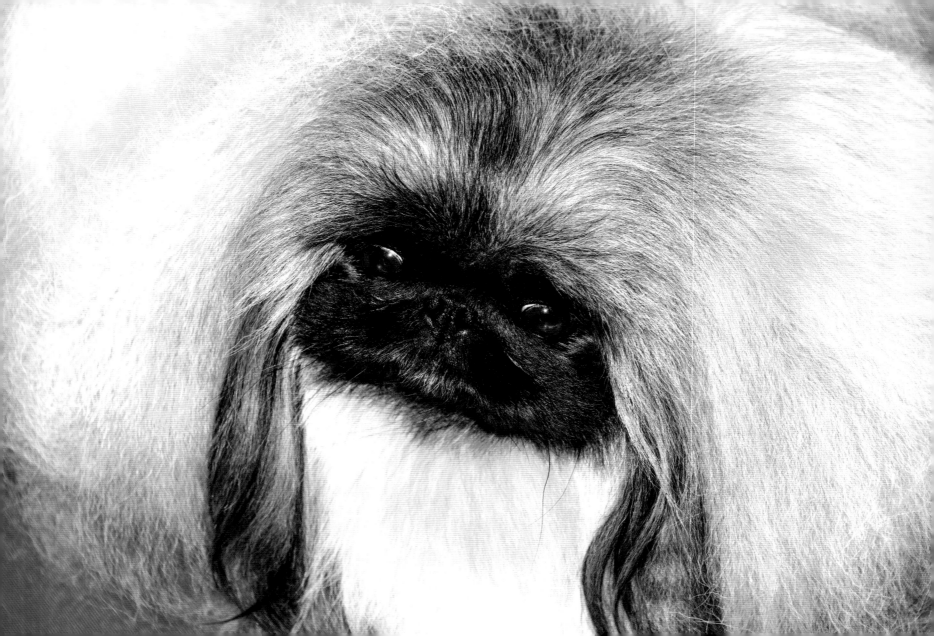

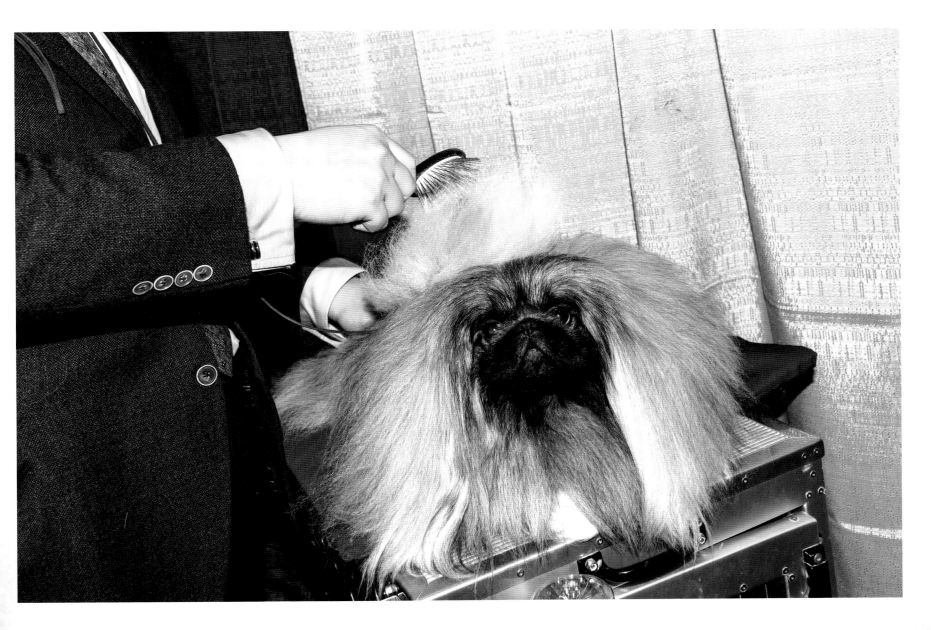

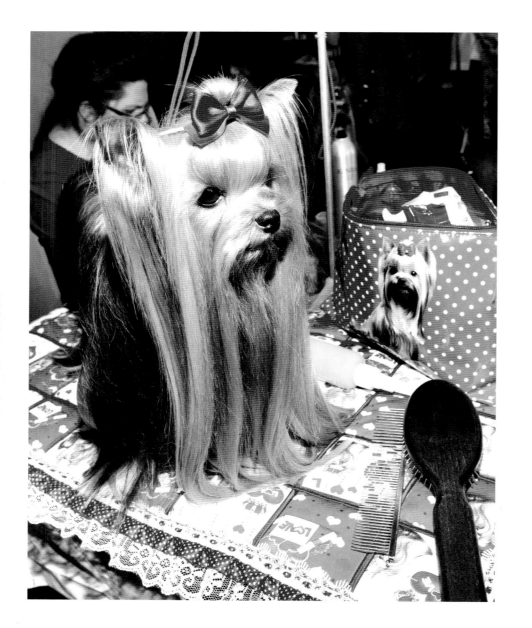

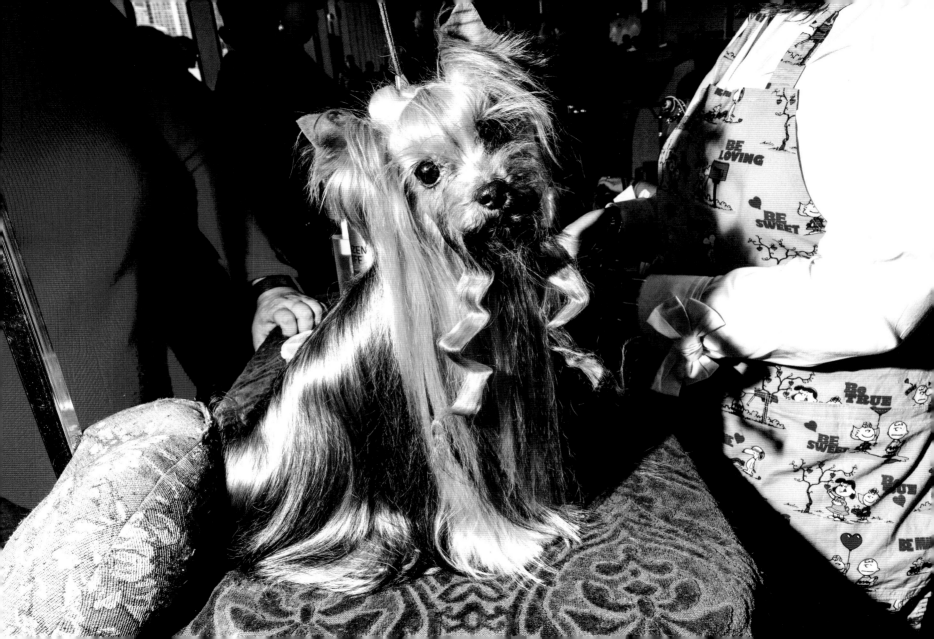

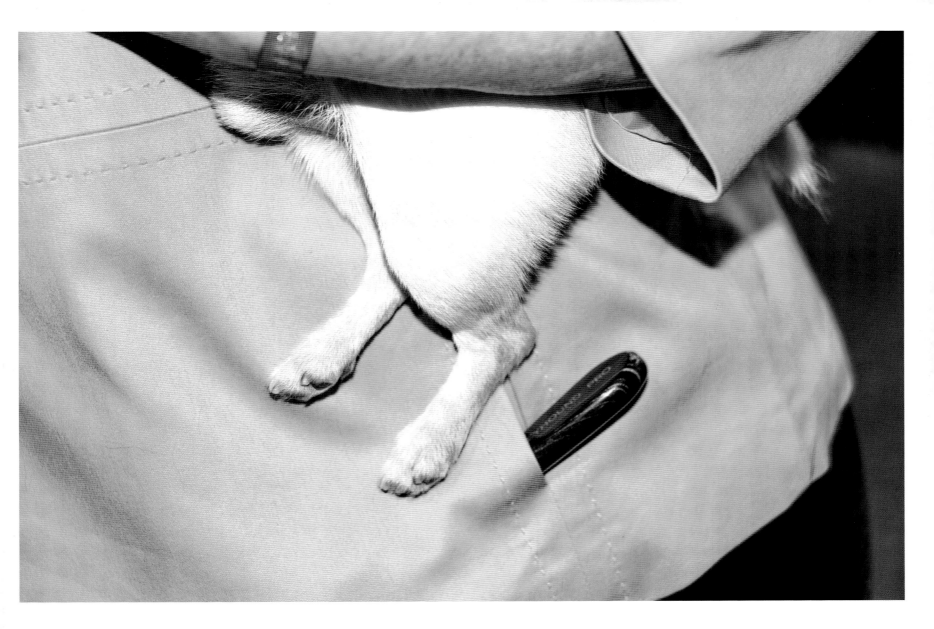

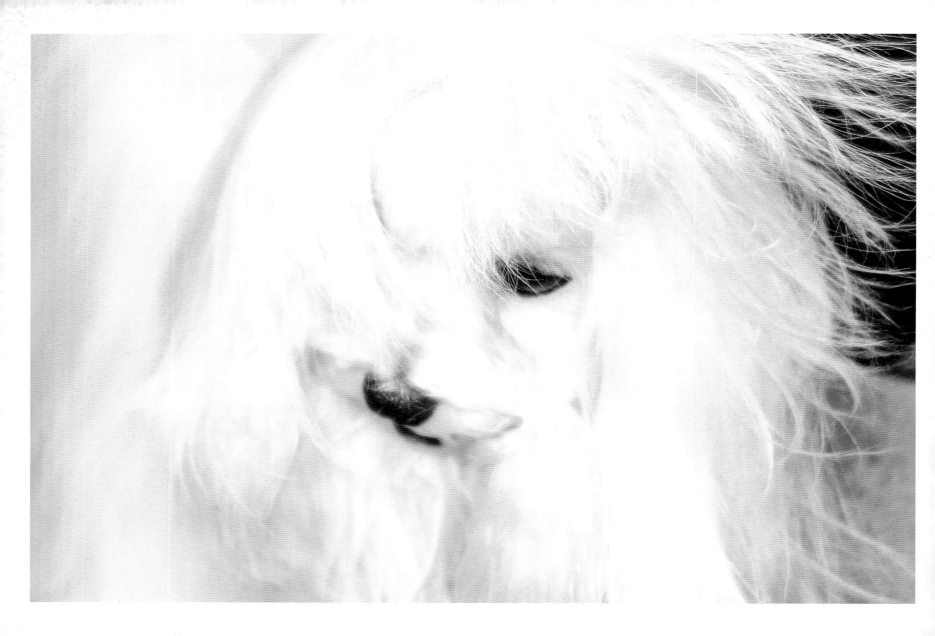

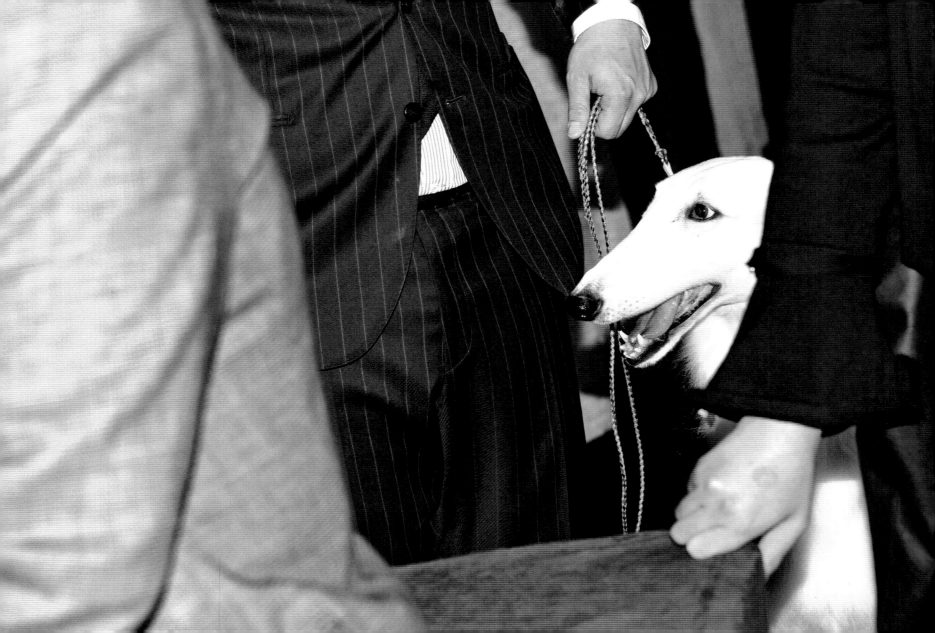

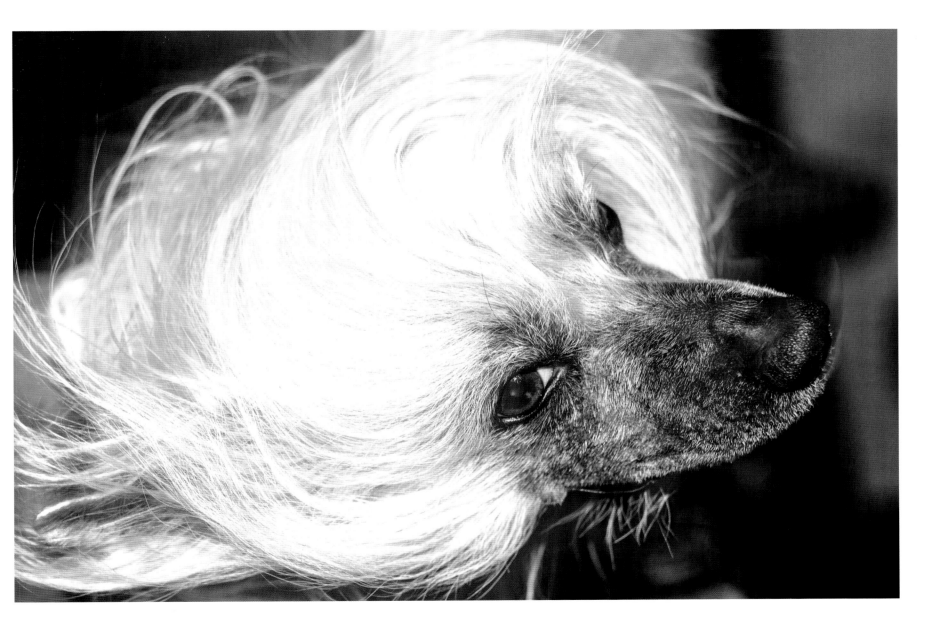

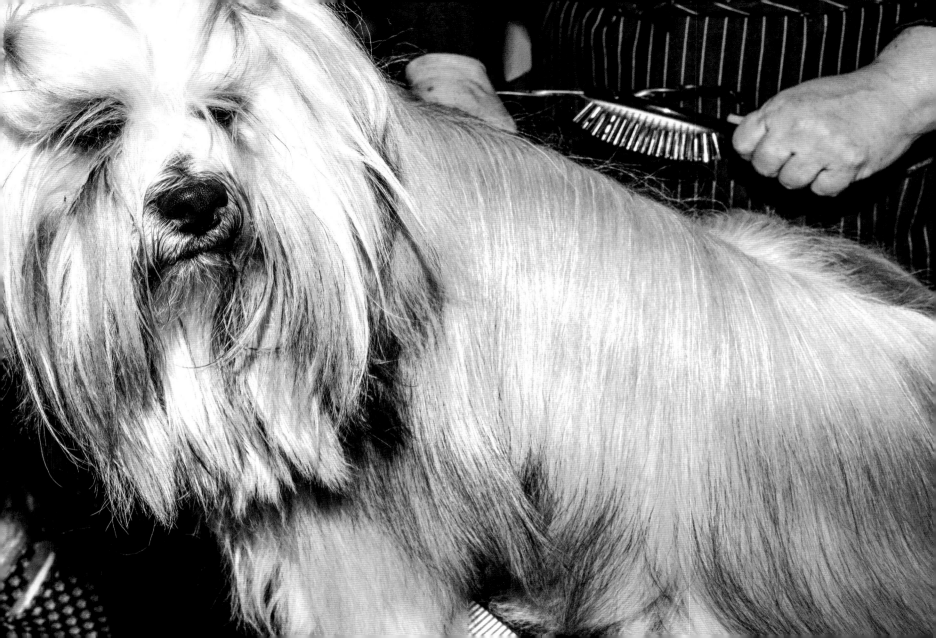

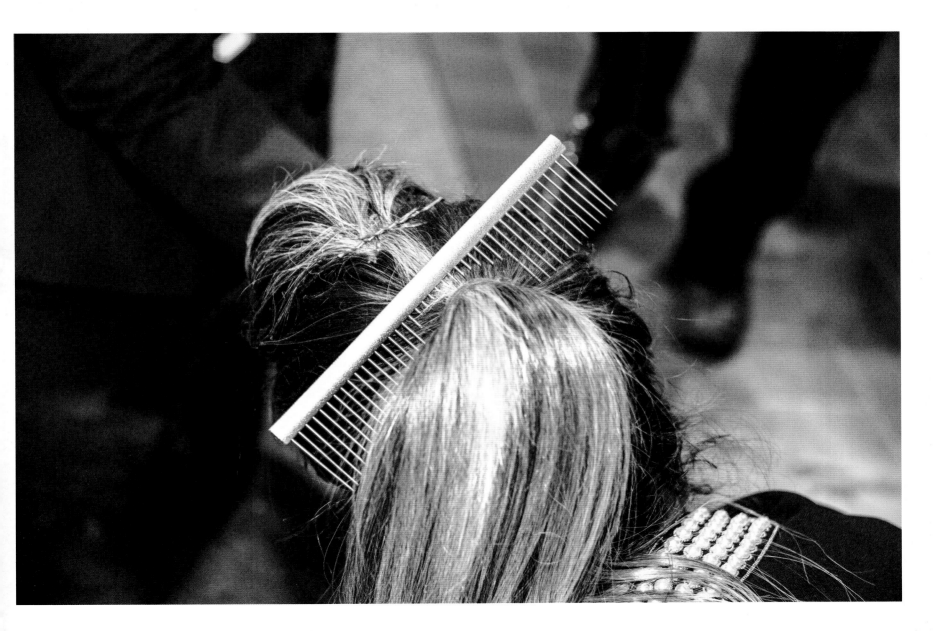

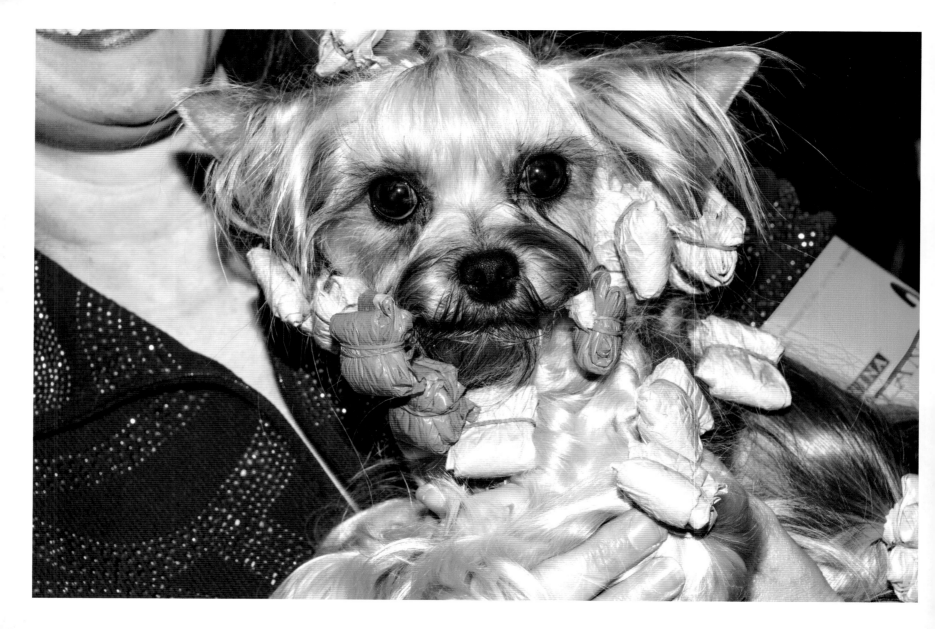

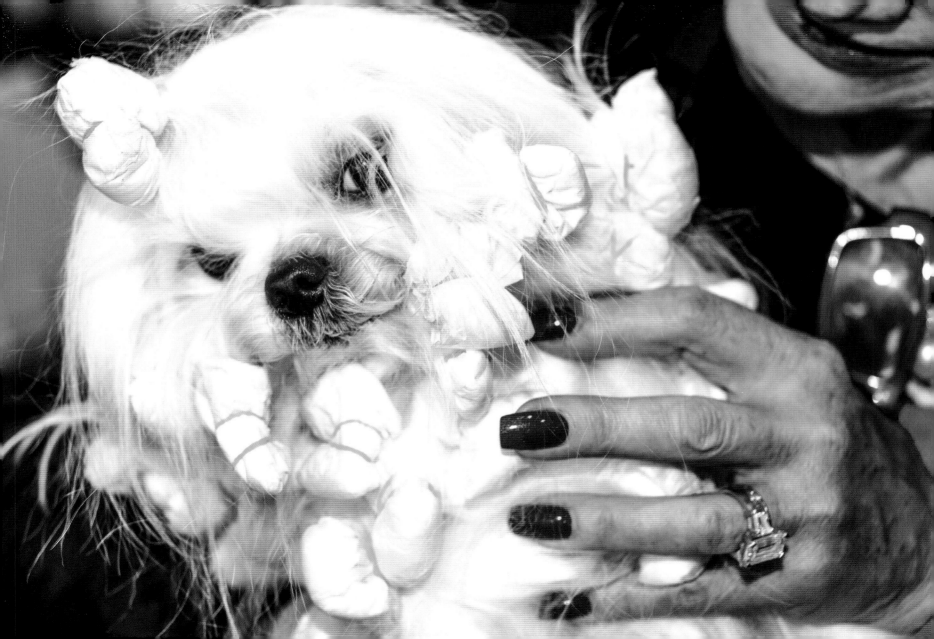

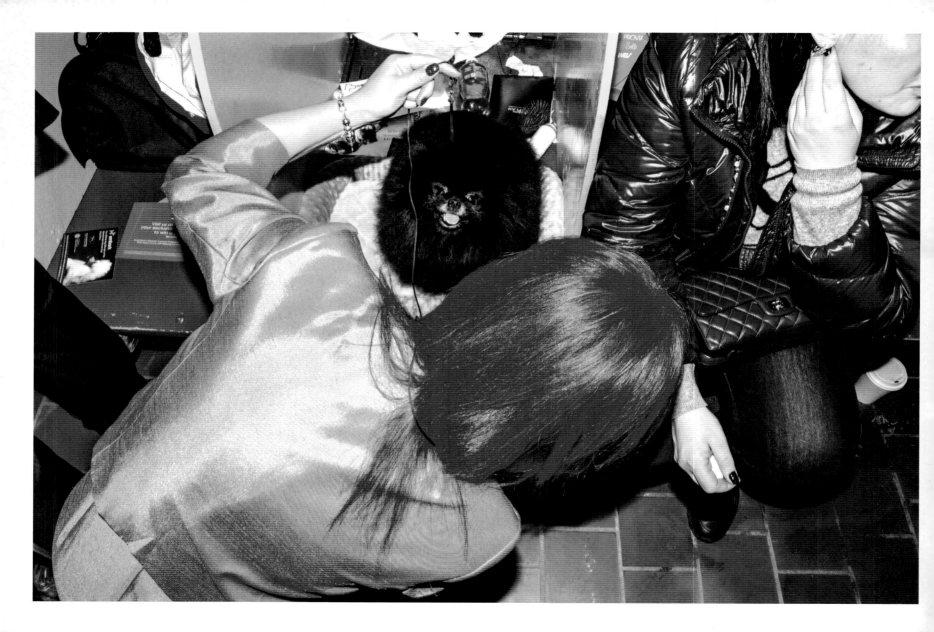

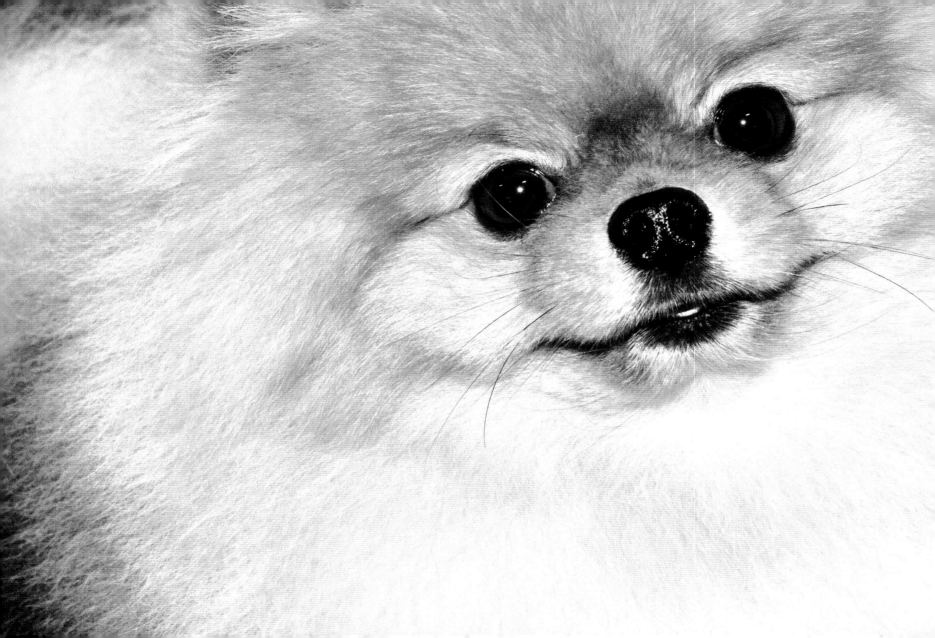

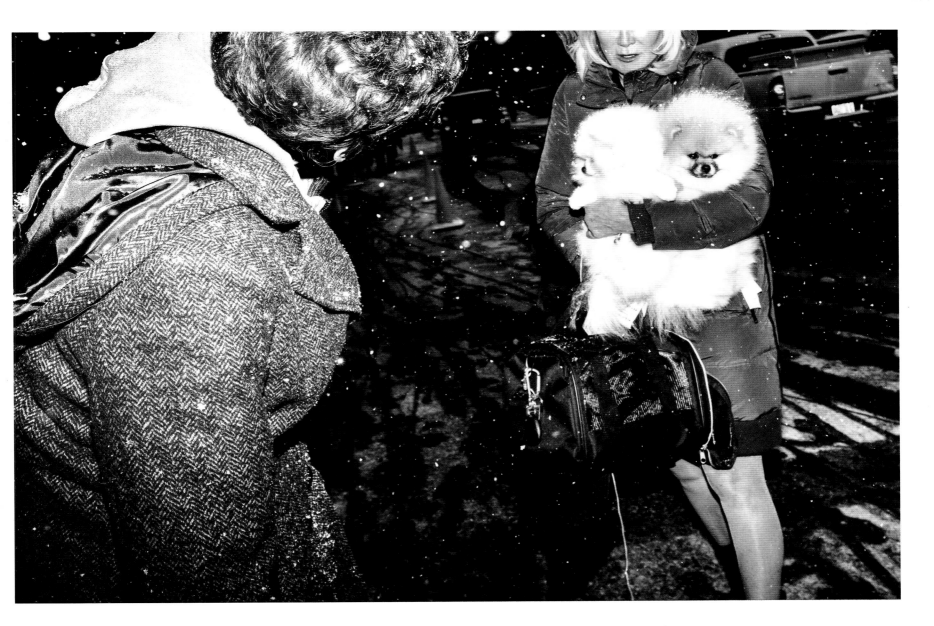

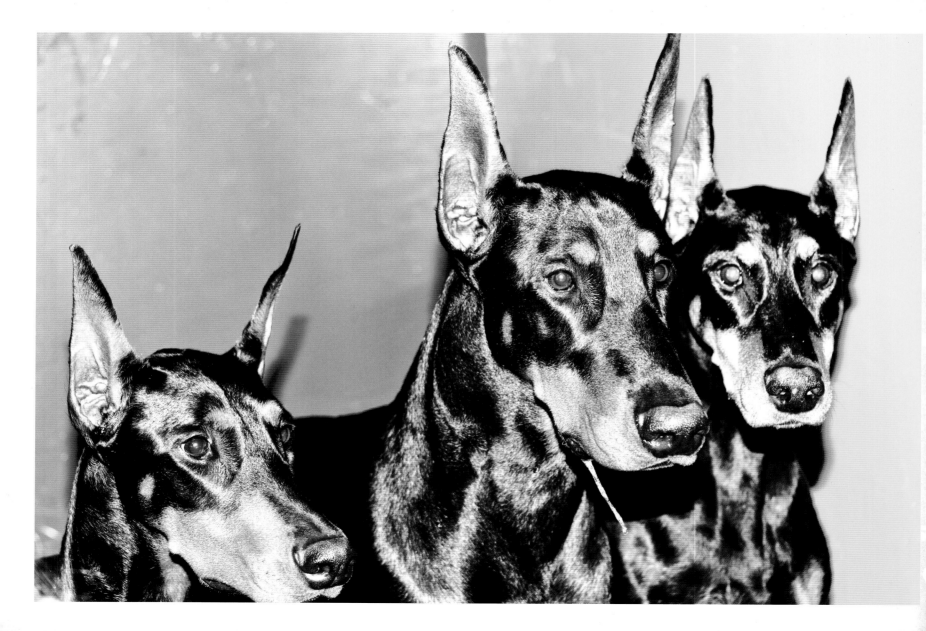

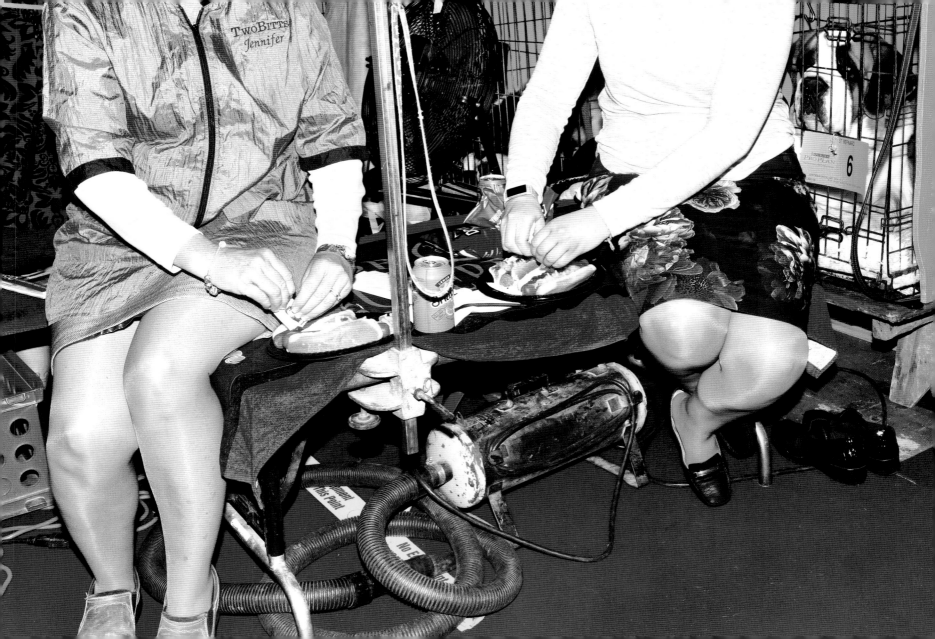

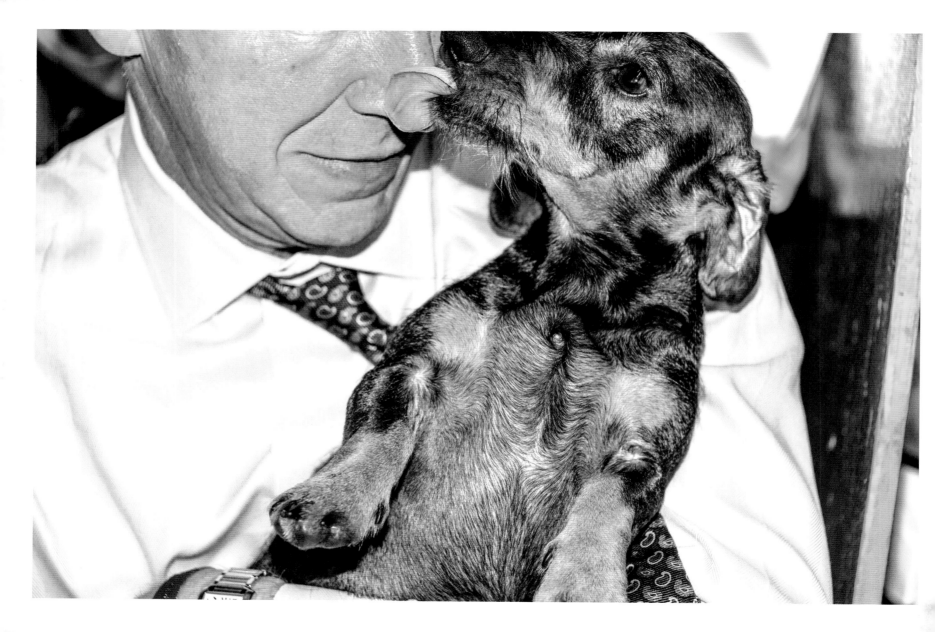

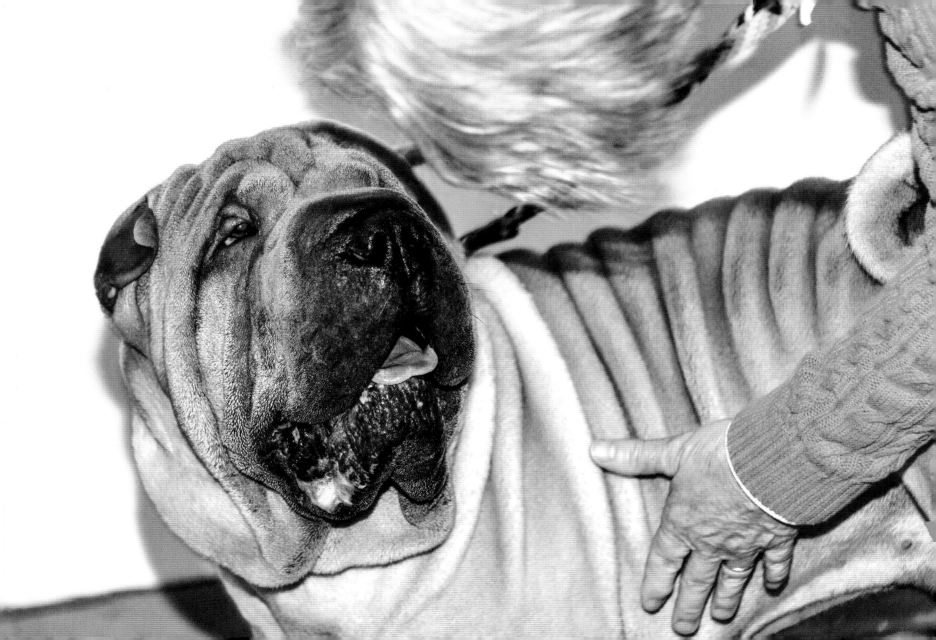

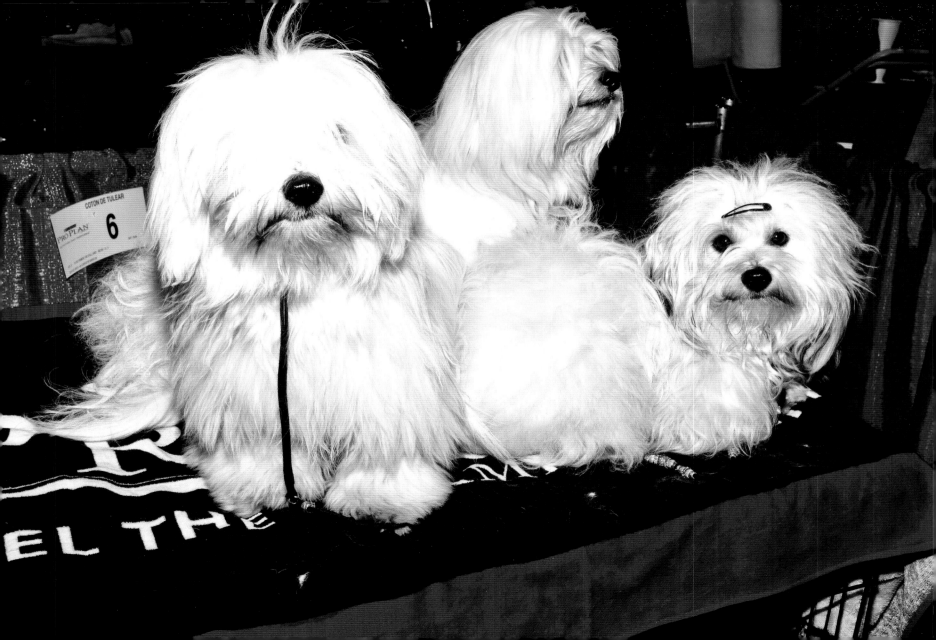

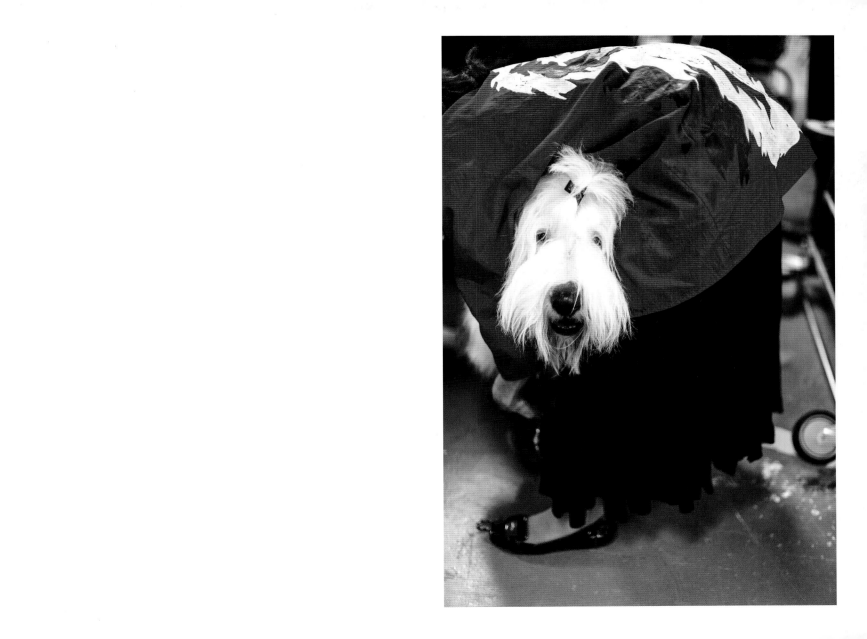

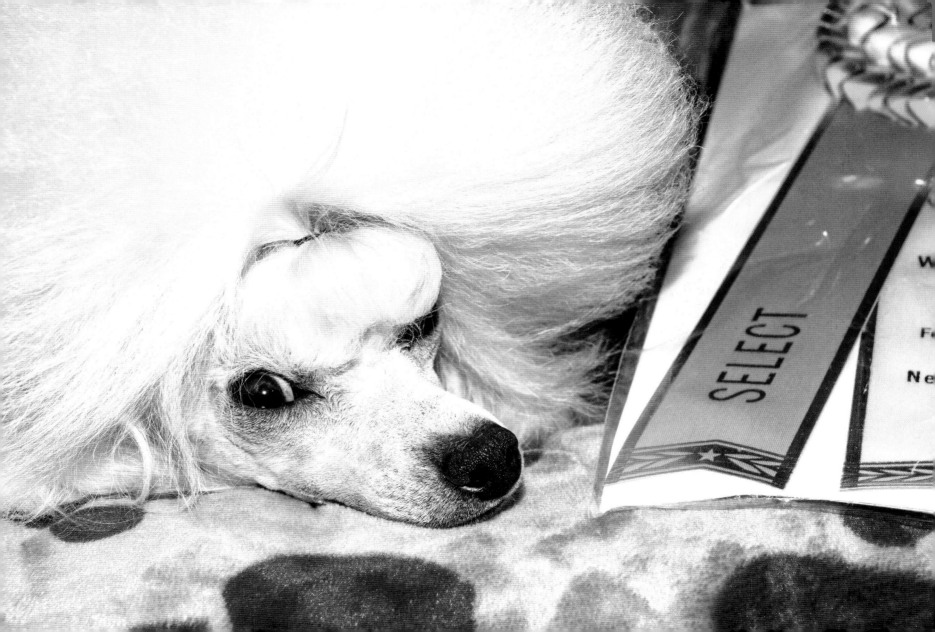

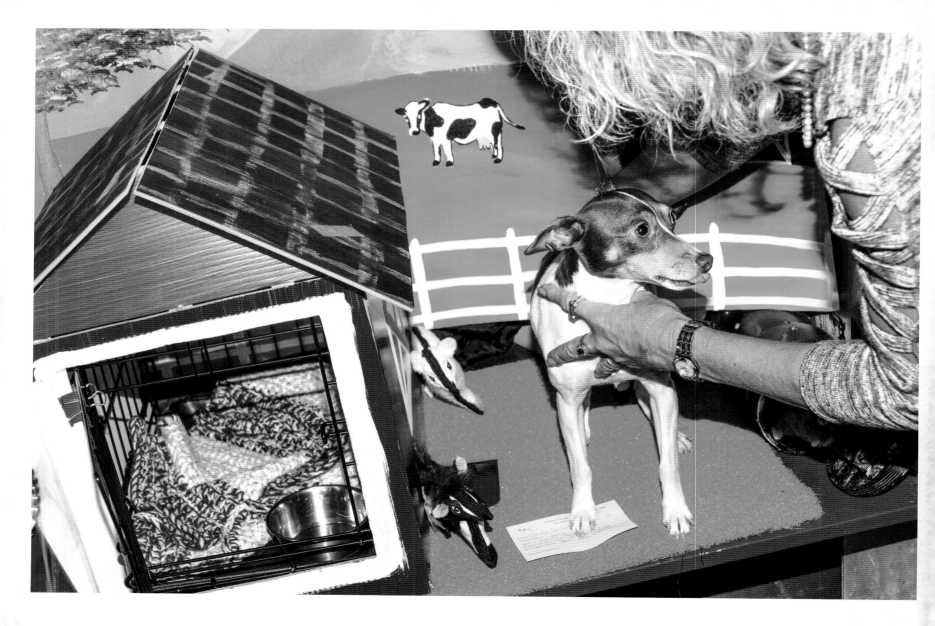

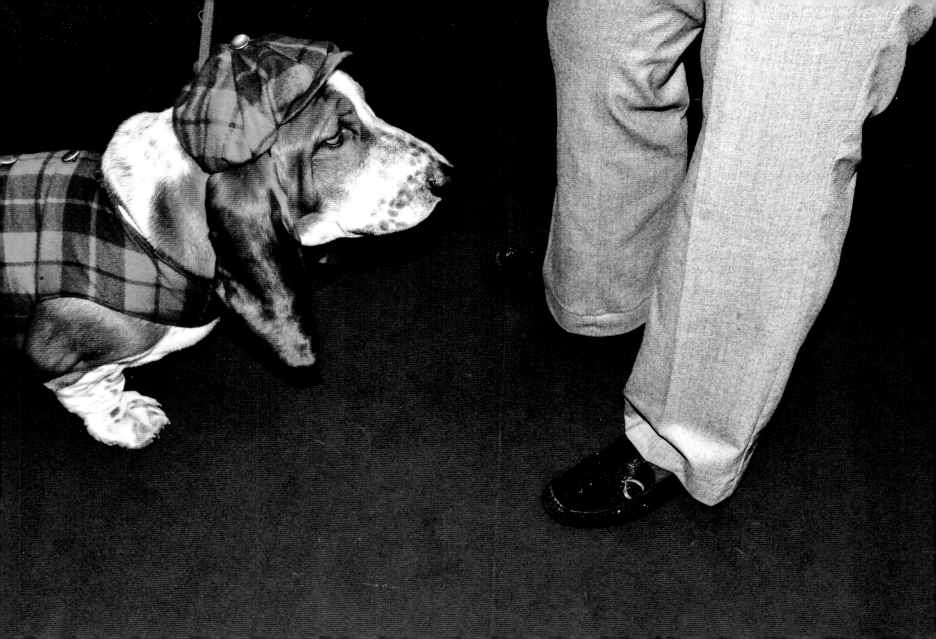

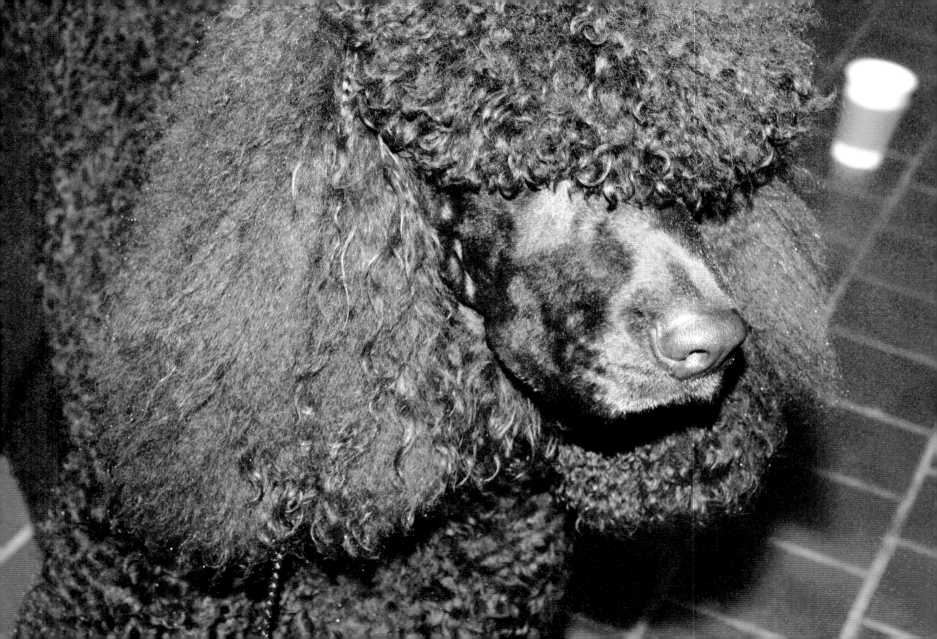

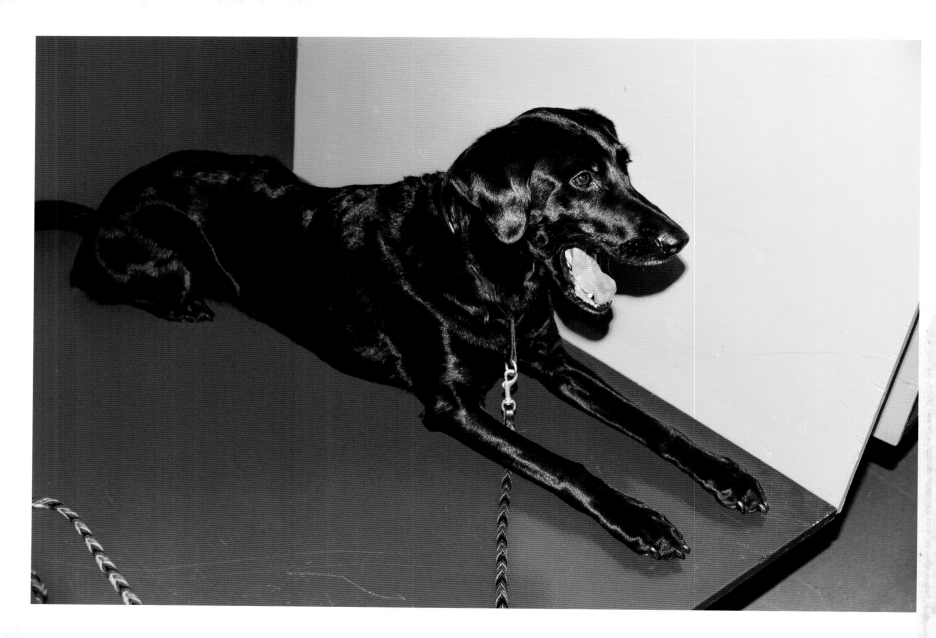

...nicle Chroma

...y Steve Alexander

...duction by Kayleigh Jankowski

ISBN: 978-1-4521-8335-0
Library of Congress Cataloging-in-Publication Data
available.

Manufactured in China

MIX
Paper from
responsible sources
FSC™ C104723

CHRONICLE CHROMA

Chronicle Chroma is an imprint of Chronicle Books
Los Angeles, California

chroniclechroma.com

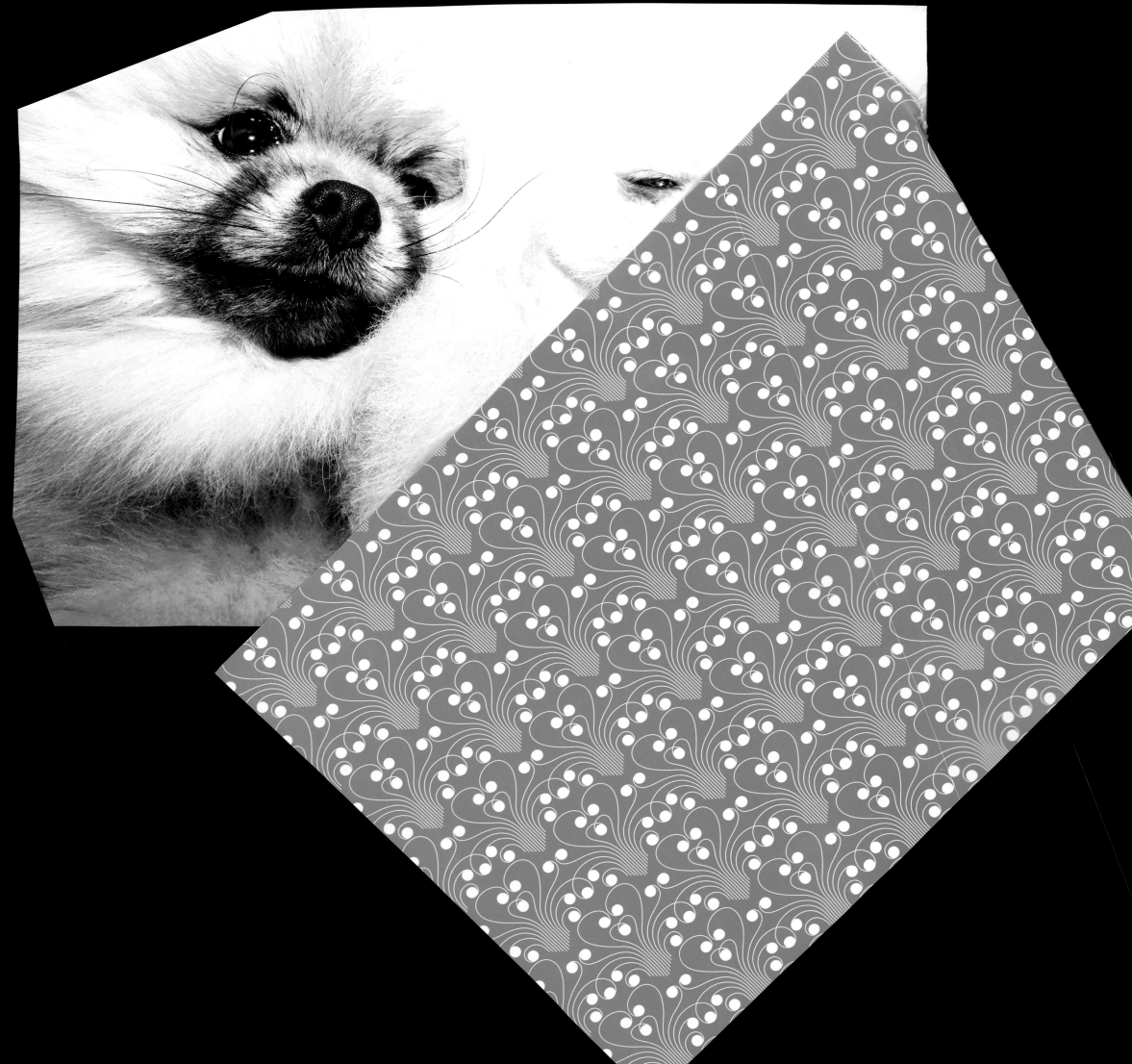